IMAGES
of America

RAINIER VALLEY

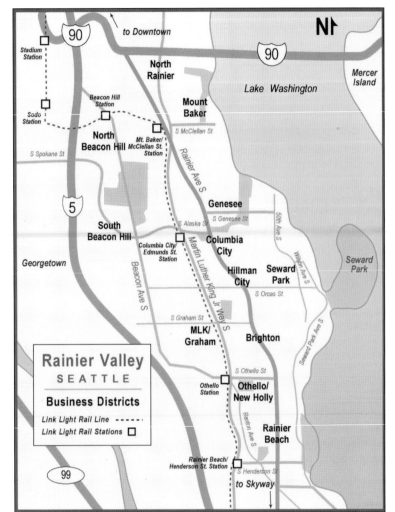

Today, Rainier Valley contains at least two-dozen named small neighborhoods, from Skyway to North Rainier. Historical names such as Tamil, York, and Garlic Gulch have disappeared from the maps but remain in song and story. (Map reprinted courtesy of the Rainier Chamber of Commerce.)

IMAGES
of America

RAINIER VALLEY

Rainier Valley Historical Society

ARCADIA
PUBLISHING

Published by Arcadia Publishing
Charleston, South Carolina

Printed in the United States of America

Library of Congress Control Number: 2011935790

For all general information, please contact Arcadia Publishing:
Telephone 843-853-2070
Fax 843-853-0044
E-mail sales@arcadiapublishing.com
For customer service and orders:
Toll-Free 1-888-313-2665

Visit us on the Internet at www.arcadiapublishing.com

*This book is dedicated to Arthur "Buzz" Anderson and all the
Pioneers of Columbia City who kept the memories alive.*

CONTENTS

ACKNOWLEDGMENTS

Our first nod goes to our predecessor organization, the Pioneers of Columbia City, whose efforts in collecting and preserving hundreds of photographs, documents, and stories form the foundation of all our work. Much of the information contained here is drawn from the research of historians Arthur "Buzz" Anderson, Carey Summers, Ruth Hall, and Mikala Woodward, among others. Buzz Anderson is the grandson of D.W. Brown, who bought the first lot in Columbia City. Both his father and grandfather appear on the cover of this book.

History has a way of growing and changing. We are indebted to the many individuals and organizations who provided vital images for the book that we did not have in our collections: the Atlantic Street Center, Gloria Cauble, the Collins family, the David Eskenazi collection, George Fleming, Alan Humphrey, the Hydroplane and Raceboat Museum, the Kubota Garden Foundation, Chuck Kusak, the Vince Mottola family, the Mount Baker Community Club, the Museum of History and Industry, Neighborhood House, the O'Brien family, Martin Patricelli, the Seattle-Rainier Lions Club, the Rainier Chamber of Commerce, James Raisbeck, the Royal Esquire Club, the Sam Smith family, the Seattle Housing Authority, SouthEast Effective Development (SEED), Bill Young, and the many student photographers of Youth in Focus.

I want to personally thank the volunteers who spent countless hours helping put together the photographs and text for this book: Connie Cox, Nancy Dulaney, Kelli Kirk, Joan Neville, and Karen O'Brien. Alan Humphrey provided technical assistance with preparing the photographs. Historian Mikala Woodward and grammarian Leslie Boba reviewed the manuscript. And finally, thanks to the entire board of directors of the Rainier Valley Historical Society for supporting and encouraging this project.

Eleanor Boba, Executive Director
Rainier Valley Historical Society

All images courtesy of Rainier Valley Historical Society unless otherwise indicated.

INTRODUCTION

The Rainier Valley cuts a wide swath from downtown Seattle southeast to the places where the city now meets up with its smaller neighbors, Renton and Tukwila. The valley was carved out by a receding glacier millennia ago. Geographically, it includes the valley floor, surrounding hillsides, and a long stretch of Lake Washington shoreline. Over decades, the landscape has been shaped by human action such as heavy timbering, the lowering of the lake level in 1916, regrading of steep hillsides, and the realignment of rivers and streams.

White explorers and settlers first arrived in the area in the 1850s, the same time that white families were building the first permanent settlement in the Seattle area at Alki Point, located eight miles to the west. In 1850, an explorer named Isaac Ebey surveyed the area by canoe and, afterward, sang its praises. His assessment was printed in an Oregon newspaper and may have influenced settlers who began arriving shortly thereafter. Of the Rainier Valley, he said, "Between Geneva Lake [Lake Washington] and Admiralty Inlet [Elliott Bay], there appears an extensive country of low land, that has never been examined by white men, and when examined I have no doubt will be found very valuable. The distance from the Inlet to Geneva Lake in many places cannot exceed a few miles, as the Indians make portages across with their canoes."

Small groups of Native Americans already had encampments at several points along the lakeshore, including a permanent village at the south end of the valley. Traditional trails followed the valley floor roughly on the route of what is now Rainier Avenue and bisected the valley at both its north and south ends.

A century and a half later, Rainier Valley, if not the most ethnically diverse region in the country, is certainly a contender for the title. It is a neighborhood that has undergone massive changes in both human and environmental terms. Where once were native footpaths are now high-traffic car and rail corridors. Virgin forests that first gave way to small farms are presently high-density residential blocks and commercial districts. The lake that forms the valley's eastern boundary was lowered in 1916 by human action, and as a result, lowland marshes dried up and an island became part of the mainland. And wave after wave of immigration has transformed the valley into a multicultural, polyglot region.

African Americans, Latinos, and immigrants from Southeast Asia, East Africa, and elsewhere followed in the footsteps of the Italians, Germans, and Irish, making new homes in this uniquely diverse community. They have formed social clubs, faith communities, and community centers. A thriving multicultural arts community includes glass blowers, painters, quilters, dancers, and poets. Food wise, the valley boasts eateries of all ethnic types, a "Restaurant Row" in Columbia City, and a popular farmers market.

Economically, there are small businesses stretching along both the Rainier Avenue and Martin Luther King Jr. Way corridors. Geographically close to the Boeing airplane plants, the Rainier Valley has waxed and waned with the airplane industry. In recent years, parts of the valley have enjoyed a renaissance of sorts as young professionals have moved into the area, while other parts

continue to suffer the effects of economic recession. Two large federally-built housing projects on the west side of the valley have been redesigned as mixed-income communities. The more affluent neighborhoods of Lakewood, Seward Park, and Mount Baker command views of Lake Washington and Mount Rainier.

The exact geographic limits of Rainier Valley are open to argument. Some visualize a neighborhood cradled between Beacon Hill to the west and the ridges to the east that divide those with lake views from those without. A few characterize the head of the valley as the area around Atlantic Street, the traditional heart of the Italian immigrant community; others take the valley as far north as Jackson Street in the Central District where Rainier Avenue was born. Some place the southern end of the valley at the city limits at Rainier Beach, while others include the unincorporated communities of Skyway and Bryn Mawr. We chose to use the broader definition of the region, including the more prosperous communities that touch Lake Washington. History does not fall neatly into boxes.

Taken all together, the population of this area is over 60,000 according to the 2010 census. At least 60 languages are spoken here, and dozens of ethnic and religious groups are represented.

To illustrate the history of this highly diverse region, we began by drawing on our own collection of photographs and printed materials, collected over more than 100 years. We then set out to fill gaps by calling on friends and associates, exploring the archives of other organizations, and coaxing community leaders to share images. Along the way, we gathered considerable new information, put new spins on old ideas, and corrected a number of long-held misconceptions.

We recognized quickly that we would not be able to cover every topic, feature every notable citizen, or discuss every beloved neighborhood institution. We apologize in advance for oversights and errors and invite you to contact us with corrections for the historical record.

One

Early Settlement

By the closing decades of the 19th century, the human geography of the Rainier Valley had taken shape. Native Americans had been largely displaced by white settlers of Western European lineage. A few Japanese farmers homesteaded in the south. The valley boasted actual neighborhoods with churches, schools, and libraries. Names of early settlers and entrepreneurs such as Hillman, Matthiesen, Wetmore, Dunlap, and Pritchard became an enduring part of the landscape in the names of streets, buildings, schools, and neighborhoods.

Lumber and farming were the two predominant industries during the early years. By 1890, several lumber mills had been established and small family farms and dairies dotted the landscape. Farmers raised vegetables, fruits, tobacco, chickens, cows, and sheep. Rough roads allowed those with horse and cart to bring goods to the more populous areas to the north, while others took their produce across Lake Washington by boat to the growing communities on the eastside.

In 1891, entrepreneur J.K. Edmiston received the go-ahead from the City of Seattle to build an electric railway that would run from downtown Seattle (by then a bustling metropolis) through the heart of the valley to Renton and possibly beyond. The Seattle, Renton & Southern Railway experienced a number of changes in name and ownership during its 46-year run. Although it operated continually at a loss, it did have a major impact on the development of the valley, as small towns and businesses clustered along its route took advantage of relatively cheap transportation. Sawmills and cabinetry businesses were able to get their goods to Seattle, a city rebuilding from the devastating fire of 1888.

The train also tempted city folk with access to cheap land. The newly platted Columbia neighborhood sold home lots in 1891 for $300: $10 down and $1 a week. Shady developer C.D. Hillman named and platted Hillman City, Atlantic City, and parts of the Seward Park neighborhood, sometimes selling them to more than one owner. The beaches and green spaces along the shores of Lake Washington were promoted as destinations for day-trippers, and the people came.

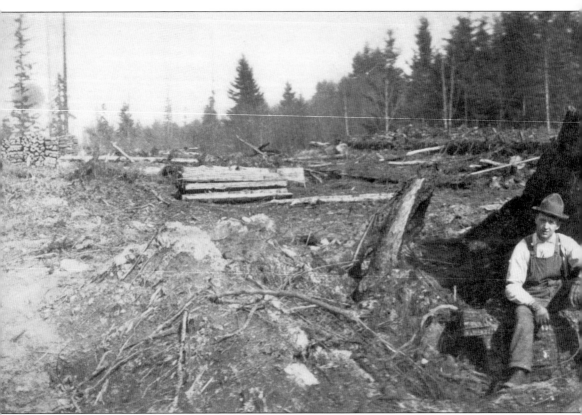

Fremont Scot Parker, nicknamed "Free Parker," rests for a moment in the hole of a stump he blasted while clearing land for his home on the edge of the Lakewood neighborhood in 1905. Parker was known as a "powder monkey," meaning that he knew how to carry and ignite explosives for the

clearing of land. New settlers often called on him to help clear their land. Roads were poor or nonexistent, so Parker carried lumber for his home on his back up the hills. Parker also served for a time as town constable for Columbia City.

This panorama photograph of the intersection of Rainier Avenue and Ferdinand Street shows the heart of Columbia City in 1899. By that time, Columbia City was an incorporated city of the fourth class; nonetheless, the town has the appearance of a frontier village with muddy roads, false storefronts, and simple frame houses. Hepler's Grocery stands on the corner with the bell

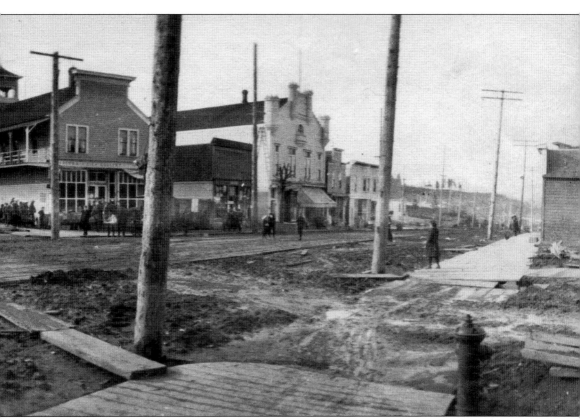

tower of the first Columbia School in the background. The two-story ornate facade building to the right is the Knights of Phythias Hall, built in 1892 as a fraternal lodge with space for retail shops on the ground floor. The two-story building on the left is Fraternity Hall, another meeting place for the town's many fraternal organizations.

In 1896, three people stand ready to cross a ravine in Columbia City. Much of the Rainier Valley was filled with sloughs, steep hillsides, and muddy fields and creeks before city and county engineers went to work reshaping the landscape. The ravine crossed by this felled log became the unofficial town dump. It was later filled in and named Columbia Park.

George Chandler and others clear timber for his Columbia City farm in 1900. Chandler noted on the image, "The log laying in front of me measured 3 ½ feet through. I had it cut up and we are now using it for fuel in our cook stove"

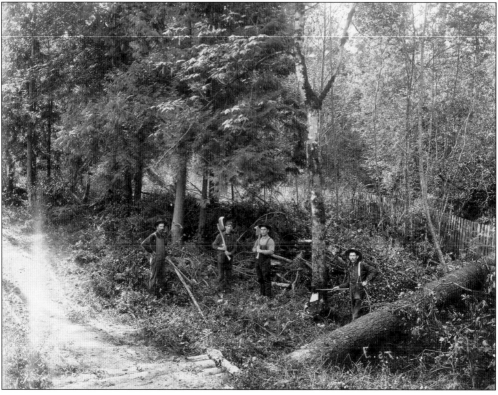

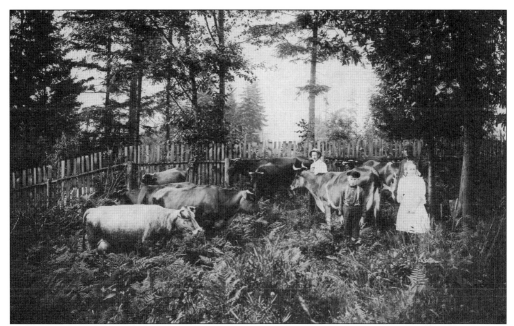

Small farms were at the heart of the valley in the late 19th century. Families grew enough produce to put food on the table, as well as barter with friends and neighbors. The Chandler family lived on their small farm at Ferdinand Street and 46th Avenue in Columbia City. The photographs show George Chandler, above, with his children, Eric and Elsie, tending their cows. In the image below, Mother Elsie Chandler feeds chickens. The 1908 images show features of the landscape such as tall timber and banked hillsides. Over the decades, people worked hard to tame the rugged terrain, although steep hills and forest remnants remain in many parts of the valley.

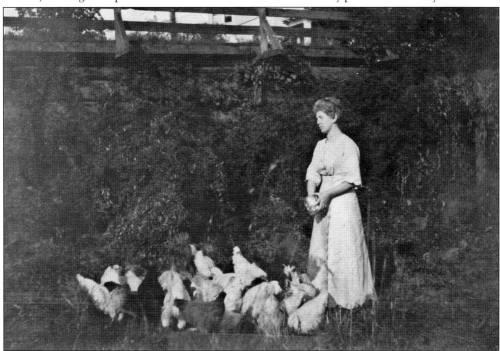

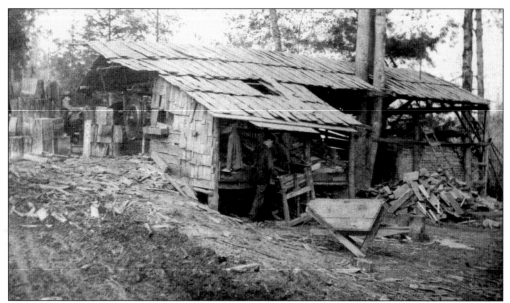

During its timbered past, the valley was home to several mills, large and small. One of the more ramshackle was Blackmer's Shingle Mill, located off Edmunds Street. A shingle mill was nothing more than a piece of machinery designed to cut shingles from logs. This photograph was taken in 1895. About 10 years later, the business closed as the supply of timber in the vicinity was exhausted.

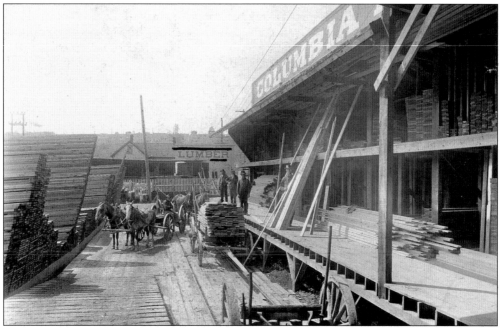

A more sophisticated milling operation existed for a number of years at the south end of Columbia City. The Columbia Mill opened in 1891 to take advantage of the huge demand for building materials in the valley and Seattle, which was still recovering from the devastating fire of 1889. The first plots for Columbia City were sold the same year, and the mill became the first commercial structure and employer of the region.

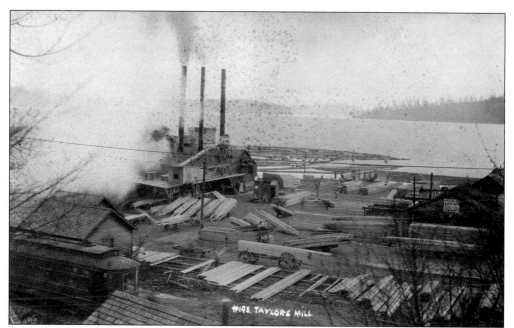

Taylor's Mill, south of Rainier Beach, replaced the original mill in the Leschi area, which was destroyed by a landslide about 1901. Logs were chuted down the steep Dead Horse Canyon, turned into planks and boards, and delivered by railcar to Seattle and Renton. A community of workers grew up at the mill site informally called Tamil. The company building still stands at 68th Avenue South on Rainier Avenue as a pizzeria.

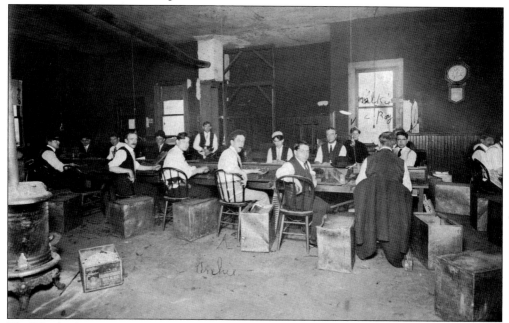

The Wright Cigar Factory, located at 5603 Rainier Avenue in Hillman City, was typical of small-sized cigar factories in the early 20th century. The workers sit around a table with several cigar rollers, and the factory was heated by a wood stove. Tobacco leaf was brought in by rail and pressed into an assortment of cigar molds of differing sizes. This photograph is dated 1906.

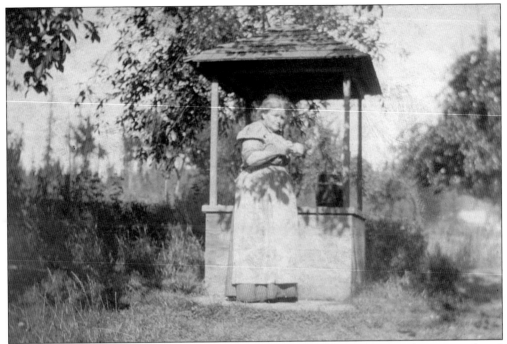

"Mama" Matthiesen stands by the family well. Her husband, Jurgen "John" Matthiesen, purchased 80 acres north of Rainier Beach on the shores of Lake Washington in 1880. To build the family house, he brought lumber by boat from his work as a sawyer at the mill at Port Madison. In 1912, the home was turned into a popular resort known as Twin Firs.

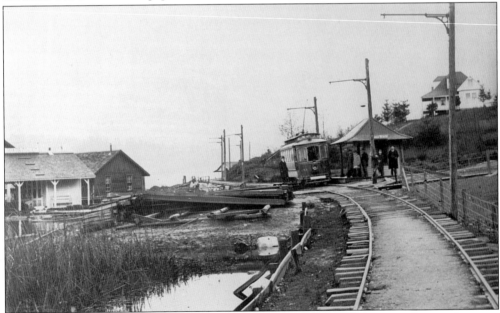

Before the lowering of Lake Washington in 1916, the streetcar tracks ran very close to the water through the Rainier Beach area. This floating home, complete with transportation, stands close to the streetcar stop in 1894. Pritchard Island is visible in the background. When the lake was dropped due to the opening of the Montlake Cut to the north, the island became a part of the mainland.

A group of neighbors enjoy a party by the lake at the Mills family cottage in 1903. The home, located on the shore of Lake Washington at 42nd Avenue and Andover Street, lost its water frontage with the lowering of the lake in 1916. It now overlooks Genesee Park.

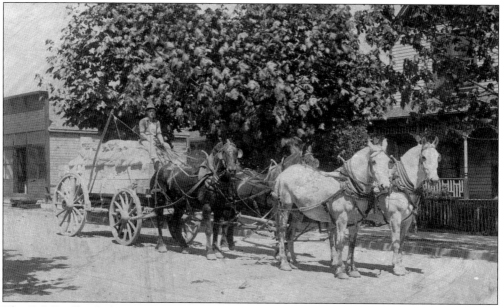

The G.S. Dudley fuel wagon waits in front of the Dudley family home at 5344 Rainier Avenue in about 1895. Two tons of lump coal cost $10. A family member noted on the back of the photograph: "The two white horses were G.S. Dudley's pride and joy. Your father had to get up WAY EARLY to feed them." Rainier Valley had an electric railroad at this time, but most families relied on coal and wood for fuel.

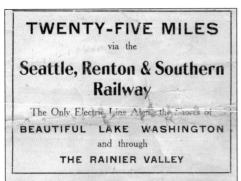

TWENTY-FIVE MILES
via the

Seattle, Renton & Southern Railway

The Only Electric Line Along the Shores of

BEAUTIFUL LAKE WASHINGTON
and through
THE RAINIER VALLEY

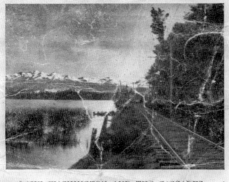

LAKE WASHINGTON AND THE CASCADES.

M C La Port

TWO HOURS OF MOUNTAIN AND WATER SCENERY

Cars start Daily from First Avenue on Washington Street at ten minutes before the hour. On Sundays, every half hour. Fare, Round Trip, 25 Cents.

J.K. Edmiston brought an electric railroad to the Rainier Valley in 1891. Both a streetcar line and a freight railroad, the Seattle, Renton & Southern Railway spurred development all along its route. This brochure touts the beauties of the Rainier Valley in hopes of attracting both day-trippers and those interested in purchasing land.

Businesses grew up along the route of the railway. This 1907 photograph shows the streetcar stop in Rainier Beach. Rainier Avenue was no more than a dirt road, thus making the streetcar a vital conduit for delivering people and goods between Seattle and Renton. The large structure is a post office/drugstore combined. Dr. J.L. Hutchinson, the father of baseball great Fred Hutchinson and Dr. William Hutchinson, had an office in the front.

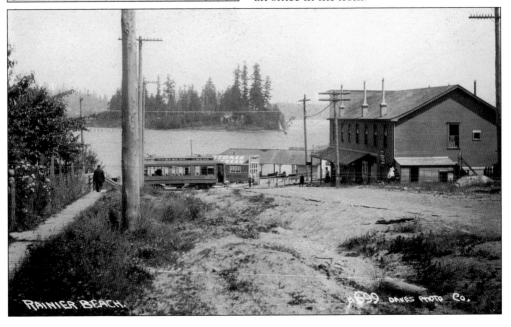

RAINIER BEACH. A899 OAKES PHOTO CO.

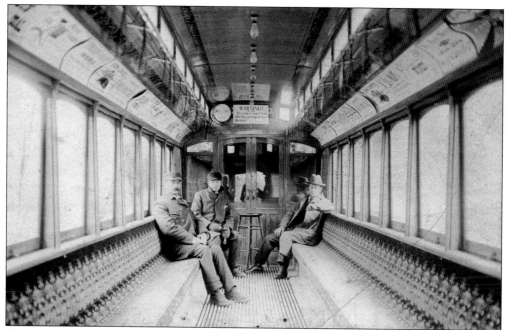

Three men sit in car no. 14 of the Seattle, Renton & Southern Railway in 1896. It was advisable to bring an umbrella along on rainy days when riding in these cars; however, rain was perhaps the least of the hazards. The history of the line is peppered with accidents, breakdowns, and even a cougar on the track.

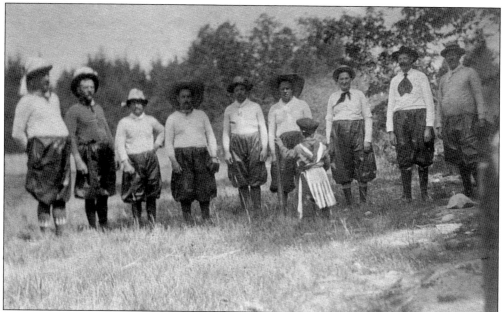

The Bloomer Boys cricket team pauses for a photograph in 1900. A cricket club stood at the southwest corner of Rainier Avenue and Charleston Street in North Rainier. Established before the streetcar, Seattle sportsmen reached the club by dirt road. The clubhouse featured a veranda with wicker chairs for spectators. Seattle's cricket club was abandoned a few years after this image was captured. The cricket meadow is now a shopping plaza.

Brighton Beach, on the shores of Lake Washington, was a popular recreation spot in 1900 when this photograph was taken. The resort hotel Twin Firs was located nearby. Here, Fred Dudley and other children play on the geographic formation known as "Big Rock," one of several glacial remnants in the valley.

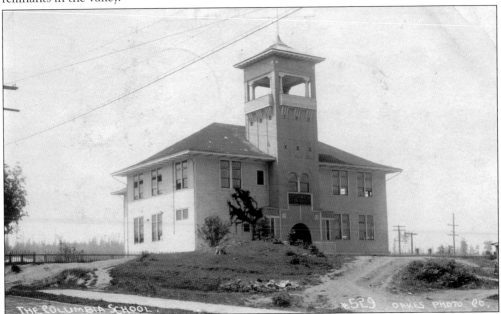

Columbia School, pictured here in 1892 shortly after it was built, is perched high on a cliff left by the grading of 37th Avenue, which was called Caldwell Street at the time. The centrally located school drew students from a wide area for kindergarten through eighth grade. It was replaced in 1923 with a one-story mission-style school that stands today.

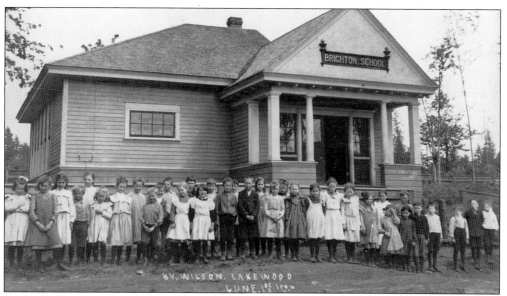

Schools were the anchor of new American communities. Here, students stand in front of Brighton Elementary at 51st Avenue and Graham Street in 1904. Opened three years earlier, the school served only first through third graders, while older children went to Columbia School. A larger Brighton School opened in 1905 on Holly Street. The first school, Little Brighton, was used off and on for overflow classes until 1946.

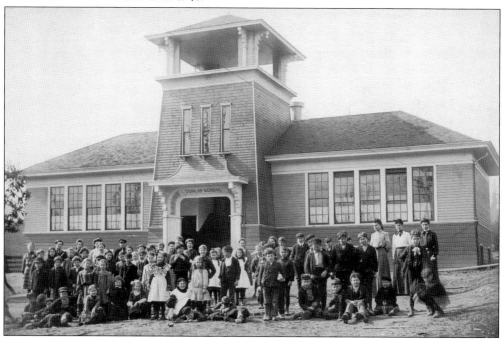

The Dunlap School on Trenton Street was built in 1904 and named for the Dunlap family, who had crossed the plains in a covered wagon and arrived in Seattle in 1869. Several street names in the valley have associations with the Dunlaps, such as Fontanelle, Henderson, and Pearl Streets. The family donated the land for this school, which replaced a one-room schoolhouse. A third Dunlap School, constructed of brick, opened in 1924.

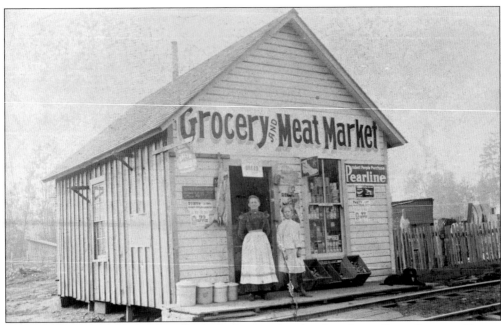

Small family groceries dotted the valley, providing goods to locals within walking distance of home. Three days after arriving from New York, Rhineholt and Louise Hausler opened their first store, seen above, in Hillman City at Rainier Avenue and Graham Street in 1901. Goods were delivered by train directly to the front porch, inches away from the rail line. In addition to food, the store sold shoes, nerve tonic, soap, and false teeth. In 1921, the family built a large brick building on Rose Street that housed a drugstore and hardware store. Louise Hausler stands with her daughter Tillie on the porch of their first small store in 1902. Below, members of the Hepler family stand in front of their store on the corner of Rainier Avenue and Ferdinand Street in Columbia City in 1902. The tower of the Columbia School can be seen in the background.

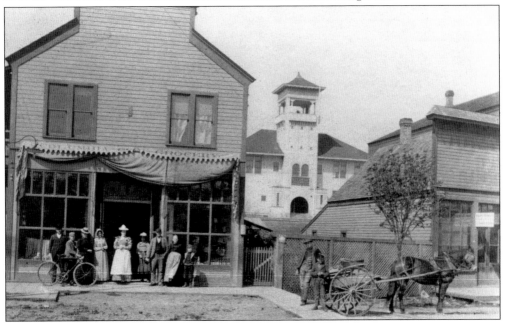

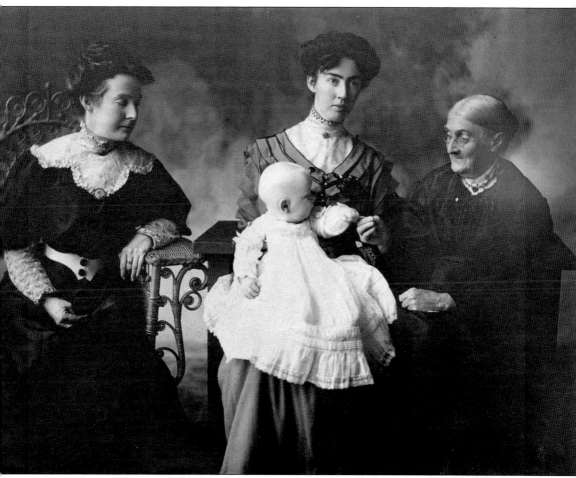

Four generations of the Hepler-Pixley family pose for a formal portrait in 1909. Morris H. Pixley, four and one-half months old, sits on the lap of his mother, Martha Hepler Pixley, while grandmother Sophronia Layne Hepler (left) and great-grandmother Frances Eastley Layne (right) look on. The Heplers and Pixleys were prominent citizens of Columbia City. Alexander and Sophronia Hepler had moved out from Iowa and opened Hepler's Grocery. Established in 1893, it was one of the oldest stores in the Rainier Valley. In the early days, the family lived above the store. Their son, Christopher R. Hepler, was a carpenter, builder, electrician, and owner of the Hepler Block. A number of Heplers served in civic capacities. At one time Martha Hepler Pixley was president of the Pioneers of Columbia City, the original historical society.

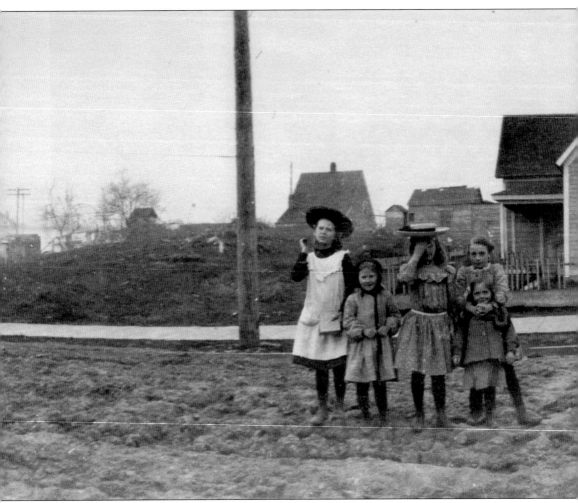

Five children stand in the middle of Ferdinand Street a half block east of Rainier Avenue in 1903. The house behind the girls was built by Van Peirson, one of the city founders and two-time mayor. Although this house no longer exists, at least two others constructed by Peirson, in 1891 and 1908, still stand on the north side of Ferdinand Street. Less than 30 years from the date

of this image, the property behind the children became home to a car dealership. The popular panoramic photograph style, which elongates the distance between structures, became common after the invention of flexible film in 1888.

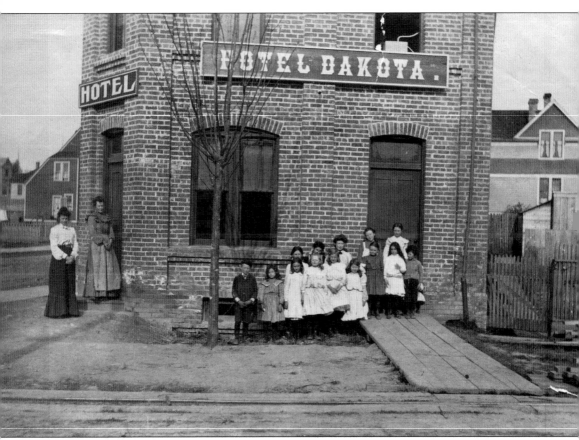

A landmark building in Columbia City, this structure was originally the private residence of the Hellenthal family in 1892, 1893, or 1896, according to various sources. It went on to serve the community as a hotel, restaurant, coffee shop, and other businesses while expanding both vertically and horizontally. At various times, it was called the Hotel Dakota and the Columbia Hotel. During the early days, the dining room offered all-you-can-eat dinners for 25¢. For a time, pigs were raised in a backyard. The building still stands at Rainier Avenue and Ferdinand Street with stucco over the brick facade. Lottie's Lounge has been a popular fixture on the corner for over a decade. The photograph, dated 1903, is captioned "Birthday party for Eunice Parker."

Two

A NEW CENTURY

Rapid growth characterized the first decades of the 20th century in the Rainier Valley. New waves of settlers arrived to take advantage of the plentiful and cheap land. Many Italians were drawn to establish farms and businesses in the north end of the valley, earning the area the nickname "Garlic Gulch." At the opposite end of the valley, several Japanese families established nurseries in the Skyway and Rainier Beach areas. Irish, German, and other families of European origin also made homes for themselves in the valley.

Neighborhood institutions were born, including Seward Park, which opened officially in 1911, and the new Franklin High School, established in 1912. Hitt's Fireworks Company set up shop on a hilltop between Columbia City and Hillman City in 1905 and continued for six decades. Dugdale Stadium was built in 1913, marking the valley as a home for baseball in Seattle.

The Rainier Avenue streetcar continued to be the critical artery of transportation between downtown Seattle and Rainier Beach and beyond to Renton, despite accidents, fare wars, and revenue loss. The roadbed was paved for car traffic in 1910. Empire Way was laid out in 1913, traversing the valley from northeast to southwest; today, it is Martin Luther King Jr. Way. The Olmsted Brothers designed a scenic route along the lakefront, connecting the Washington Park Arboretum with Seward Park. In many places, steep hillsides were regraded to create manageable roadbeds.

As the small communities of the valley grew into each other, annexation to the city of Seattle became all but inevitable. By 1907, Seattle had annexed all Rainier Valley communities except the unincorporated southern neighborhoods of Skyway and Bryn Mawr. In 1916, the opening of the ship canal between Lake Union and Lake Washington lowered the level of the lake, drastically changing the topography of the valley. Swamps and creeks dried up, at least one small island became part of the mainland, and new waterfront property opened up for development. In Columbia City, hopes of establishing a functioning port by dredging Wetmore Slough dried up along with the marshland.

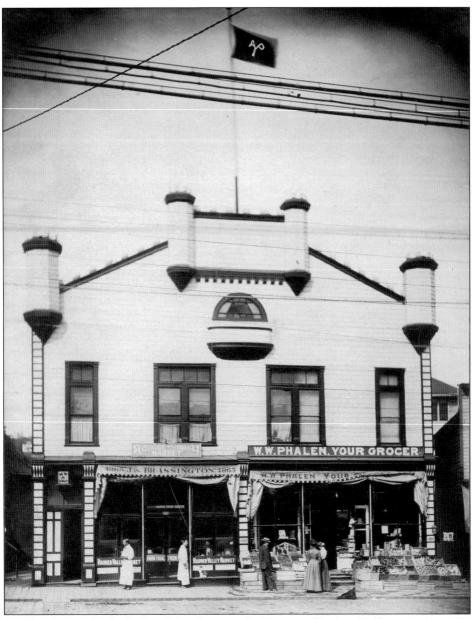

The earliest fraternal lodge hall in Columbia City, the Knights of Pythias Hall, was built in 1892 at 4863 Rainier Avenue as a two-story wooden building with a castle-like facade. Bill Phalen bought the building soon after his arrival in Columbia City in 1901, and W.W. Phalen, Your Grocer, located on the ground floor, quickly became the largest grocery in the area with several horse-drawn delivery wagons servicing the hinterlands. The upper story, which served as a lodge hall, dance hall, and gathering place, became known as Phalen's Hall. The entrance to the hall can be seen on the left. An Alaska-Yukon-Pacific Exposition flag atop the pole dates this photograph to 1909. In 1941, a fire originating in the broom closet of the ground floor bakery destroyed the top floor. The oak-reinforced dance floor upstairs may have saved the first floor, which stands today. The Knights of Pythias also continue to this day, although in reduced numbers. The Pythian Temple in Tacoma, still owned by the order, is in the National Register of Historic Places.

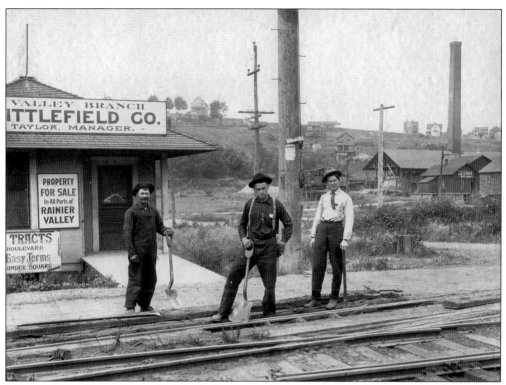

Men work on the tracks at the North Rainier trolley stop. The realty sign indicates that the valley was still wide open for development in 1909. The buildings at right make up the W.C. Hill Brick Company, lending the stop at Dearborn Street and Rainier Avenue the informal name of the Brickyard Station.

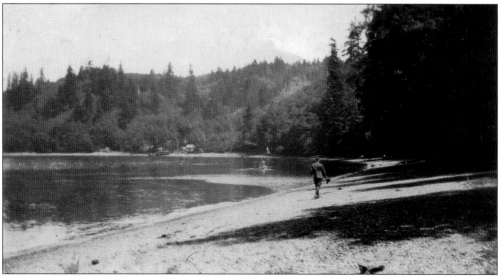

A man strolls along the shore of what is now Seward Park about 1920. In 1911, after years of unsuccessful negotiations to purchase this forested peninsula from the Bailey family, the City of Seattle forced the sale through eminent domain, paying $1,500 per acre. It became Seward Park, which was part of the Olmsted Brothers' park plan for the city.

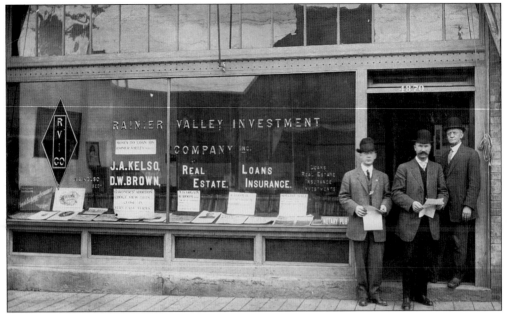

This 1908 photograph shows, from left to right, A.B. Watson, D.W. Brown, and J.A. Kelso standing in the doorway of the Rainier Valley Investment Company at 4870 Rainier Avenue. As Columbia City prospered, so did the company, and in 1913, a fine new brick building designed by local architect Henderson Ryan was constructed across the street on the former site of Hepler's Grocery. A sign in the window reads, "Money to loan on Rainier Valley Property."

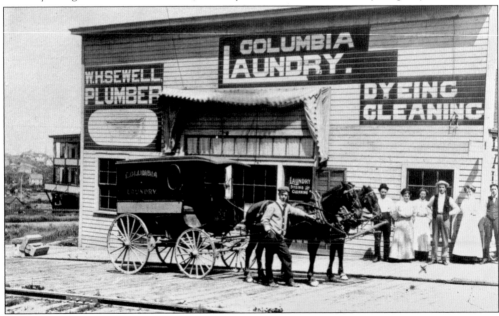

In the early years, many Rainier Valley women did their laundry with a wooden tub and washboard. By 1911, the Columbia Laundry staff at 4810 Rainier Avenue was ready to starch and mangle shirts, collars, and cuffs with pick-up and delivery available. Although the first electric washing machine patent was issued in 1910, it is unlikely there were home washing machines in the valley for at least another decade.

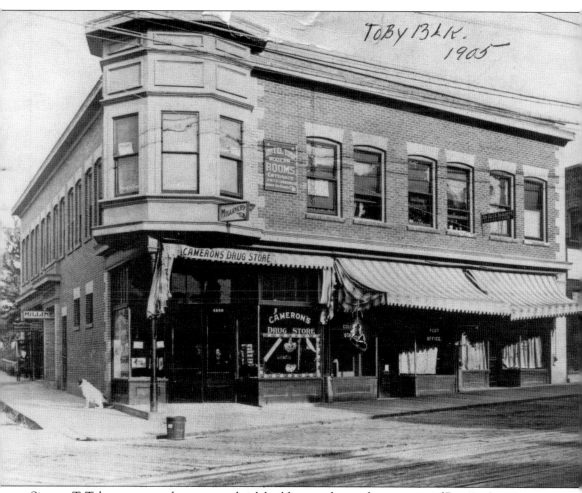

Simeon T. Toby constructed a two-story brick building on the southeast corner of Rainier Avenue and Edmunds Street in 1903. A third story was added in 1914. In 1909, Toby opened Columbia City's first bank, which came to be known as the Rainier Valley State Bank. Over the years, the Toby Building served as home to many businesses, including Grayson Brothers Hardware and Furniture, Cameron's Drugstore, the Columbia Station Post Office, and a basement pool hall. Bathrooms for the pool room were built out under the Edmunds Street sidewalk. Toby is also remembered as the "Father of Columbian Way" for his role in persuading the Seattle City Council to build a road from Columbia City over Beacon Hill to Georgetown and West Seattle in 1927. A plaque honoring him adorns the north wall of the Toby Building.

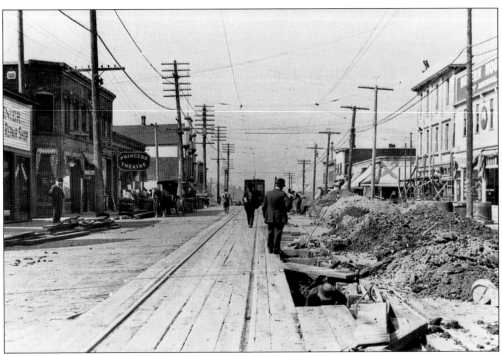

Looking north on Rainier from Hudson Street, the photographer captured street construction in progress during 1913. Seen on the left, the Princess Theatre, which operated from 1912 to 1921, was likely the first movie theater in the area. Local youngsters enjoyed many Keystone Cops and Charlie Chaplin matinees there.

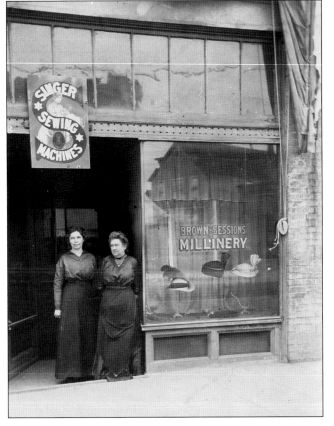

Brown & Sessions Millinery shop in Columbia City, one of the first women-owned businesses in the valley, opened about 1914. Jennie Sessions had gone to millinery school in New York with Mrs. Brown. Hats featuring black velvet and ostrich feathers on wide brims were considered fashionable at the time.

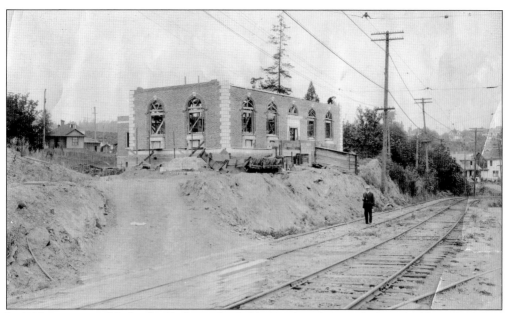

In 1912, a portion of Columbia Park was deeded by Frank and Kate Black to the library board for the construction of the Columbia Branch Library. Local citizens contributed $2,500 towards the purchase of the new site, with philanthropist Andrew Carnegie donating $35,000 to include all furniture and fittings. With great civic pride and 6,670 books, the library opened on December 30, 1915. A committee of Rainier Valley ladies greeted visitors.

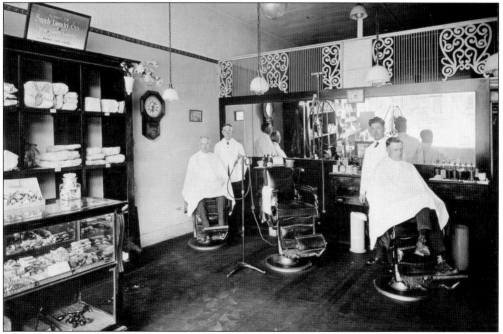

The Rainier Valley Barber Shop, owned by Lee Gardner and Menzo LaPorte, was located at 4866 Rainier Avenue from 1908 to 1923. Corncob pipes, cigars, and candy are visible in the display cases. Just out of view is a pocket billiards table. In those days mixing pool and barbering was fairly common. LaPorte, always recognizable by his signature pompadour, stands on the right.

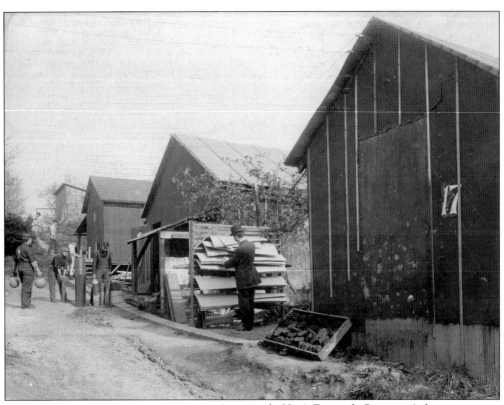

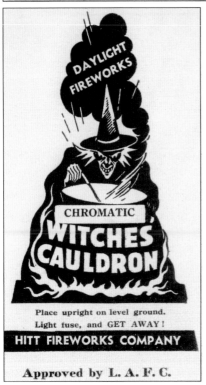

DAYLIGHT FIREWORKS

CHROMATIC
WITCHES CAULDRON

Place upright on level ground.
Light fuse, and GET AWAY!

HITT FIREWORKS COMPANY

Approved by L. A. F. C.

At its peak, Hitt's Firework Company's four-acre factory site on the hill between Columbia City and Hillman City consisted of about 30 manufacturing and storage sheds and employed some 200 people. Above, employee Sam Young, standing on the left, carries two round shells while founder T.G. Hitt, wearing a derby, stands in the foreground. From local shows for the Rainier District Pow Wow to famous Hollywood movie scenes, Hitt's fireworks dazzled for nearly 70 years. They were featured at the 1909 Alaska-Yukon-Pacific Exposition in Seattle, as well as the San Francisco and New York World's Fairs. Hitt's also manufactured fireworks and novelties for home use, including the Witches Cauldron and their popular Flashcracka. (Both, courtesy of Gloria Cauble.)

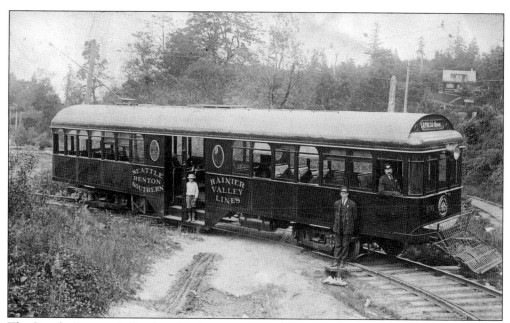

The Seattle, Renton & Southern Railway was the only independently owned electric interurban railway line in Seattle. Car no. 106, built by the Moran Shipyards on Seattle's waterfront, was placed into service in 1910 and was the last car to operate when the financially ruined railway was ordered to cease operations by the Seattle City Council in late 1936 to make way for busses.

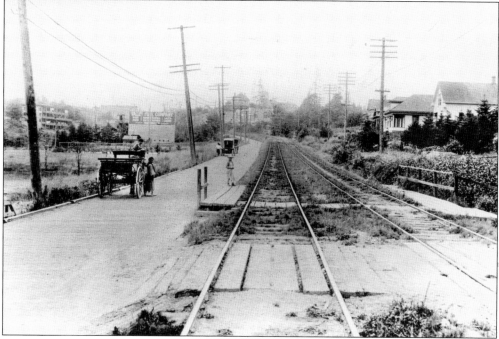

The view south along Rainier Avenue from the Genesee Station towards Columbia City in about 1913 reveals the Columbia Library under construction in the distance. Because of mud, the original two-lane dirt roadway was covered with planks laid crosswise for an eight-mile stretch, making for a rough ride for horse-drawn buggies and wagons.

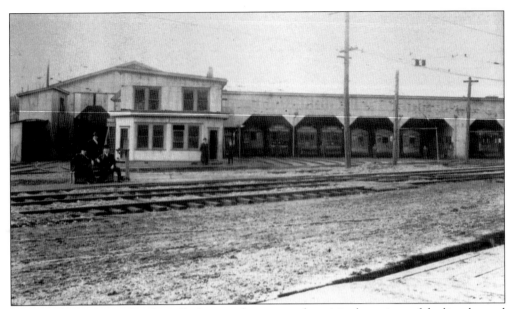

The Seattle, Renton & Southern Railway car barns were the original terminus of the line, located on the west side of Rainier Avenue between Hudson and Dawson Streets. Later, the line was extended all the way south to Renton. The streetcar provided employment for many locals as conductors, linemen, and mechanics. The last car rolled into the barn shortly after midnight on January 1, 1937. The barns were demolished soon after.

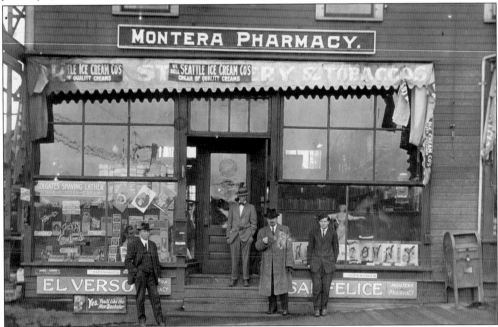

Montera Pharmacy was located on the corner of Rainier Avenue and 57th Street in Rainier Beach. The men in this 1909 photograph are, from left to right, Andrew Matthiesen, unidentified, Dr. J.L. Hutchinson, and George Gardner. Dr. Hutchinson was the father of baseball great Fred Hutchinson and Dr. William Hutchinson, the founder of the Fred Hutchinson Cancer Research Center. The elder Hutchinson made house calls on horseback as far away as Kennydale and Black Diamond.

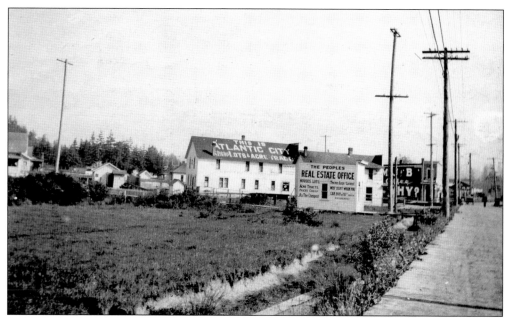

In 1905, Clarence "C.D." Hillman purchased one of the tracts homesteaded by the Dunlap family near Rainier Beach and designated it the Atlantic City Addition. After making millions in various real estate schemes, Hillman was exposed as an unscrupulous, though colorful, businessman and spent 18 months behind bars at McNeil Island Prison. Today, he is most remembered as the man behind the development of the Hillman City neighborhood.

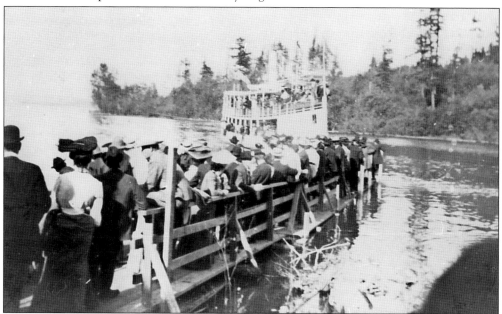

One sunny morning in 1902, a crowd of prospective real estate buyers rode the Yesler cable car from downtown Seattle to Leschi Park. They then boarded the *L.T. Haas* steamer for a cruise along the shoreline to Lakewood Landing, likely at the foot of Genesee Street, where many attractive home sites were available. Guy Phinney, a wealthy lumber mill owner, purchased and platted Lakewood in 1883.

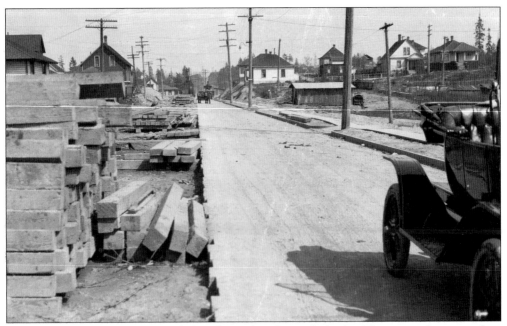

In 1913, Genesee Street was graded and paved with wood planks. The steam-driven grading machine is in the distance next to a team of horses. On the left are railroad ties used in laying rails for the Genesee shuttle streetcar, also known as the "Genesee Dinky" or "Galloping Goose," among other nicknames. The Dinky ran under a wooden overpass at 48th Avenue and then south on 50th Avenue to Hudson Street.

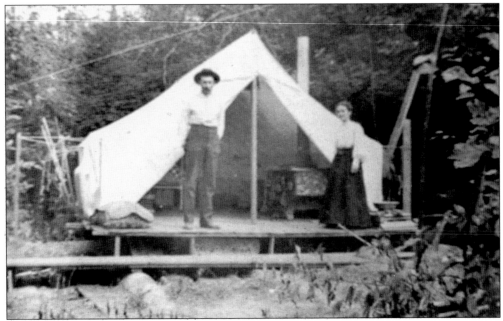

The Reimers purchased a lot in the Othello neighborhood in the early 1900s. As a first step, they erected a tent atop a wooden frame and floor. A wood range was installed with a stove pipe through the roof. Access to the new home was via the county road, earlier an Indian trail, which ran from Beacon Hill south to Renton along much of today's Renton Avenue South.

Looking west from Rainier Avenue along Holly Street in this 1908 image reveals the second Brighton School in the distance. By 1907, the school had 300 pupils but no playground. Brighton mothers took their demands for a play area, baseball suits, and swings to the school district. Initially ignored, they organized as an official parent-teacher association (PTA) and were eventually successful in getting their playground.

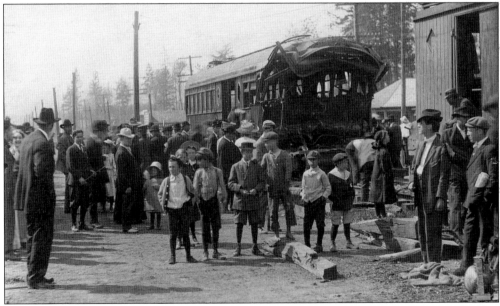

A crowd gathers around streetcar no. 102, which was struck by a runaway coal car at Willow Street in 1910. Two passengers were killed and twenty injured. The motorman of the doomed car escaped injury by jumping out the window. One passenger, concerned her ticket might not be honored on another streetcar, refused to get off. This was one of the more serious accidents involving the trolley line.

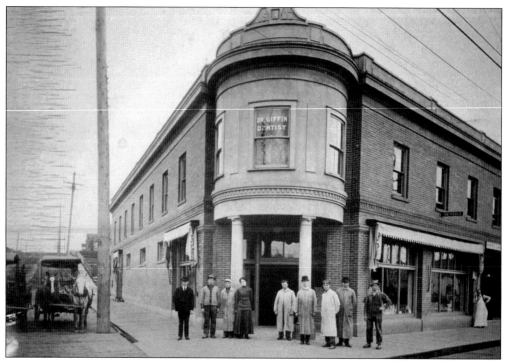

John Keefe (far left) came west by wagon train in 1889 and then left Seattle for the Alaska Gold Rush of 1897. At Chilkoot Pass, he and his brother Richard (eighth from the left) mined the miners by selling provisions and building boats. With their earnings, they returned to Seattle and opened the Keefe Grocery in Hillman City at the northwest corner of Rainier Avenue and Orcas Street in 1903.

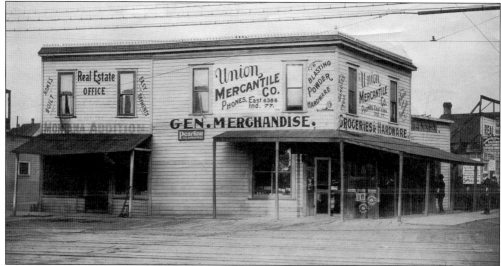

The Union Mercantile Company was located on the northeast corner of Rainier Avenue and Orcas Street in 1904. The company had two phone numbers because the two competing telephone companies in the area could not transfer calls. By this time, Hillman City boasted a new baker, furniture shop, pool hall, meat market, real estate office, and its own drinking fountain for horses.

In 1905, Rhineholt and Louise Hausler purchased some land from C.D. Hillman and moved their grocery from Graham Street to a new two-story wooden building on Rose Street. They called it Atlantic Market and Grocery, adding a hardware store and delivery service with an apartment for themselves on the second floor. In the photograph at right, Rhineholt Hausler poses with his grandson Jack in about 1915. With the success of their enterprise, the family went on to erect an even larger commercial building. The completed Hausler building (below) at Rainier Avenue and Rose Street was the finest in the area when it was constructed in 1921. It housed Hausler's grocery, as well as a drugstore, furniture retailer, meat market, and barbershop. The previous Hausler store building can be seen on the left.

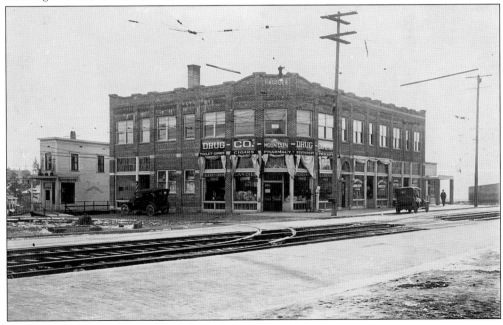

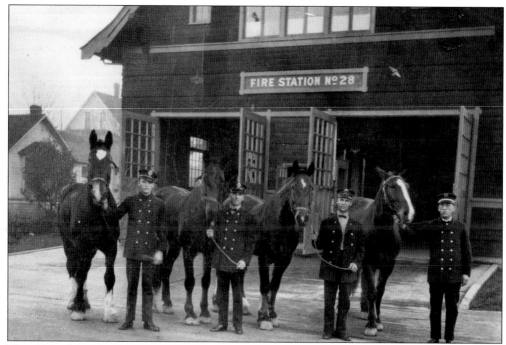

The original Fire Station 28, built around 1909, was just east of Rainier Avenue on Orcas Street. By 1915, the Hillman City station was the longest established and largest of the three stations serving the Rainier Valley. Horses pulled the equipment, and as one longtime resident recalled, there was "nothing but sparks as they wheeled around the corner!"

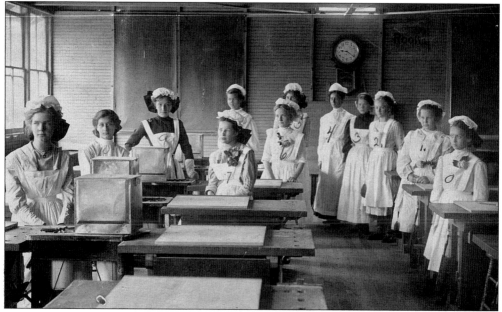

In 1911, cooking classes were part of the required curriculum for girls, as were manual trades for boys, in the old Columbia School. Very few married women worked outside of the home. Note the gas burners and breadboards for making baked goods. The numeral "4" identifies teacher Miss Cunningham overseeing the budding homemakers.

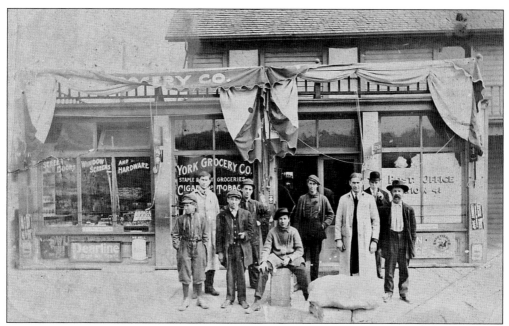

York Station, originally known as Wetmore, was a stop on the streetcar line north of Columbia City. A small business district soon grew up around the station, including York Grocery, York Pharmacy, and Browne & Loranger Cash Grocery. A York Grocery Company ad in 1916 offered "Fancy and Staple Groceries, Hardware, Hay and Grain." Cash groceries required payment at the time of purchase, whereas other stores allowed customers to charge purchases on account. One Rainier Valley grocer was reported to have accrued $40,000 on accounts during the Depression, money that was still owed when he closed his store in the early 1980s.

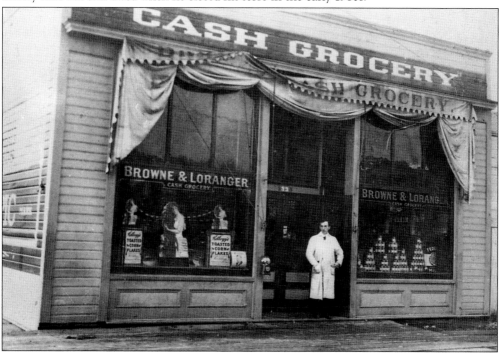

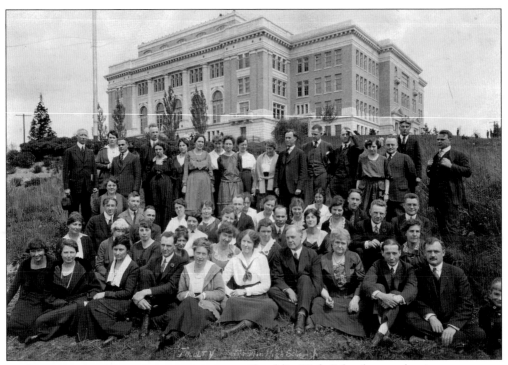

Franklin High School opened at its present site in September 1912. From the beginning, the school was filled to capacity. This Franklin faculty of 1919 taught classes hit hard by World War I. A number of local boys had enlisted in the armed forces; seven did not return home. Students on the home front supported the war effort with Red Cross work and donations to the YMCA War Fund.

Franklin High's *Tolo* magazine, published monthly from 1911 through 1919, featured student artwork and articles covering current events, creative writing, and the latest in teenage observations. The January 1916 edition opens with Ralph Waldo Emerson's poem "The Snow Storm." The February issue reported that, during a 21-inch record snowfall, Mr. Stilwell from the science department was felled by a snowball "hot shot" to the delight of onlookers.

46

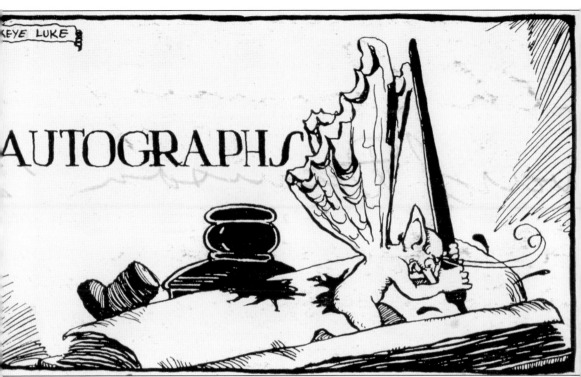

Actor Keye Luke (1904–1991), one of Franklin High's graduates, is most often remembered as Charlie Chan's "Number One Son" in the popular series of detective movies in the 1930s. His years at Franklin High School seem to have destined him for a much different career. He was not in the school's dramatic club, but rather a member of the art club and art editor of the *Tolo*. The 1922 *Tolo Annual* contains over a dozen Keye Luke fantasy line drawings such as this one. He also played indoor baseball and midget basketball during his formative years. Fellow students were assured that Luke would become a graphic artist. An essay titled "Prophecy—Class of '22" foresaw fellow graduate "Burton Edwards sitting for the renowned artist, Keye Luke, as a model for magazine covers." In fact, Luke did take his art to Hollywood, painting movie set murals and producing publicity materials for *King Kong* (1933) and other films before landing his first uncredited role in *The Painted Veil* in 1934. He also painted portions of Grauman's Chinese Theatre.

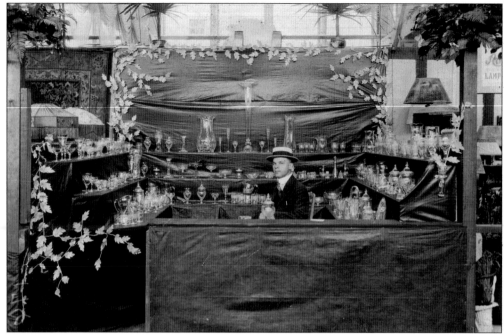

Moravian-born Anton Kusak arrived in Seattle in the winter of 1914 and, in short order, persuaded major retailer Frederick & Nelsen to carry his fine engraved crystal stemware; the relationship lasted 70 years. In 1926, the first Kusak freestanding glass-engraving factory was built at 1303 Rainier Avenue. Three generations later, Kusak Cut Glass Works is still a flourishing Rainier Valley business. (Courtesy of Chuck Kusak).

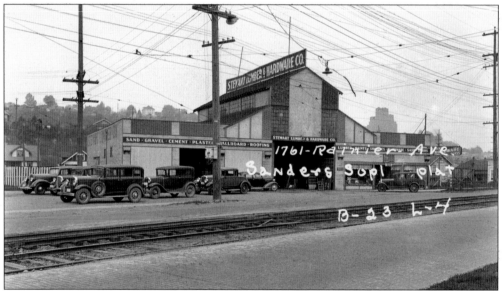

The Stewart Lumber & Hardware Company was built at 1761 Rainier Avenue around 1920. The Young family purchased the business in 1926, and it continues to this day in its original location. For many years, lumber was delivered on a streetcar spur that ran right through the building. Other early lumber businesses included Lakewood & Mount Baker Lumber, City Sash and Door, and Orvis Lumber. (Courtesy of Bill Young.)

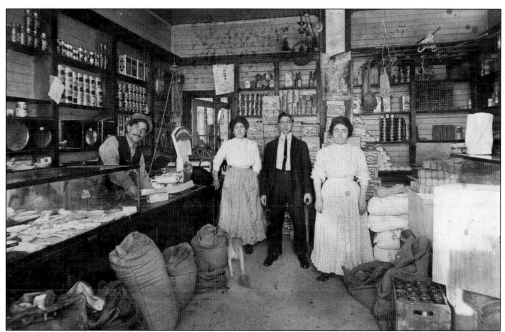

After the turn of the century, the neighborhood around Atlantic Street was so heavily dominated by Italians, it became known as "Garlic Gulch." There were several Italian grocery stores, as well as an Italian pharmacy, Italian language school, barbershop, macaroni factory, and of course, Borracchini's Bakery. The Vacca brothers' farm and its produce stand, Pre's Garden Patch, were popular draws. Pictured above is a typical Italian grocery, possibly Padine's on 26th Avenue. Below, Italian men relax at Seward Park following Mass, while the women prepare the Sunday repast. In 1940, Interstate 90 sliced through the heart of the Italian community in North Rainier and tunneled through the Mount Baker neighborhood to reach Lake Washington and the first floating bridge. Garlic Gulch never fully recovered. (Both, courtesy of Martin Patricelli.)

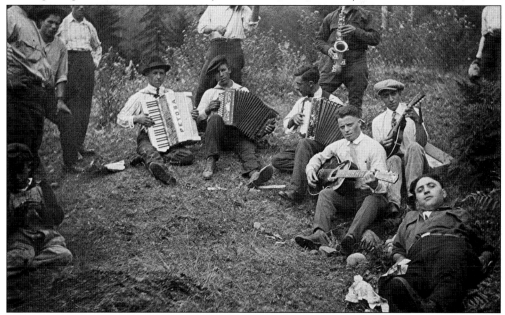

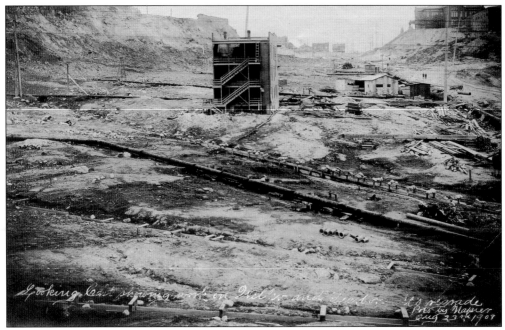

In 1909, a regrade of Dearborn Street sluiced away more than a million cubic yards of earth, greatly improving access between downtown and the Rainier Valley. The change benefitted farmers who trucked their produce to the Pike Place Market. The earth removed was used to fill in the Puget Sound tide flats that came up to the base of Beacon Hill's west side.

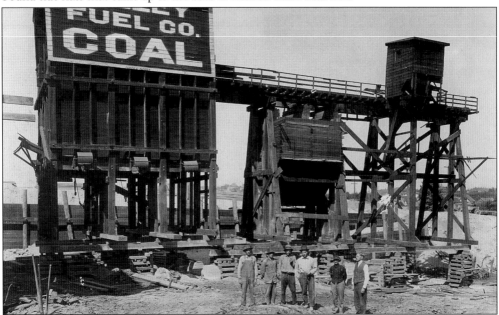

Valley Fuel Company stood on the southeast corner of Rainier Avenue and Alaska Street. A spur off the streetcar tracks allowed coal cars to get to the bunkers in a ravine. This 1912 photograph shows the coalbunkers being raised to match the level of the tracks after a recent Rainier Avenue regrade. As demand for coal diminished, the bunkers were adapted to handle sand, gravel, and other materials.

McClellan Street, pictured here in 1911, was the main artery connecting the planned community of Mount Baker Park to the valley and on up to Beacon Hill. The Hunter Improvement Company, which platted the neighborhood in 1907, created a spur trolley line along McClellan to connect with the Rainier Avenue trolley. The building on the right is the original commercial building, which housed the Mount Baker Clubhouse on the upper floor.

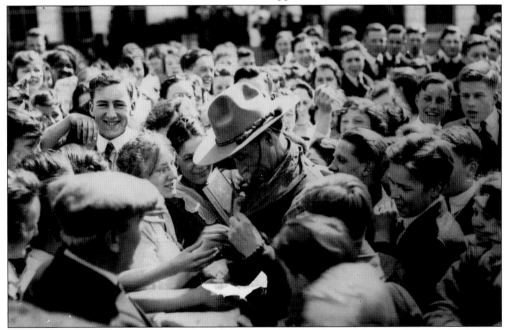

Silent film star William S. Hart signs autographs for adoring fans at Franklin High School. Hart is credited with helping shape the iconic Hollywood cowboy—rough, ready, and sober. Already 56 when this image was captured in 1920, he did not make a successful transition to talkies. In the photograph, Hart wears his trademark outfit, complete with a Stetson hat.

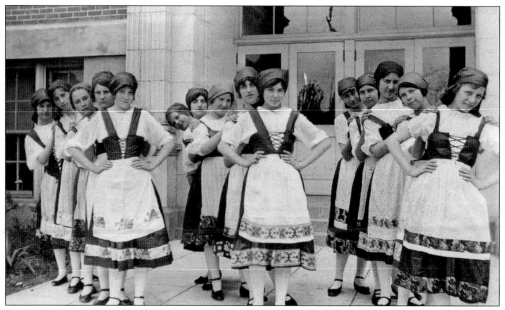

Costumed seventh and eighth grade girls perform a May Day dance at Emerson School. The school was built in 1909 on a hill above Rainier Beach. This School Children's Summer Festival at Emerson Playfield was held in 1914. That same year, the school opened the first public kindergarten in Seattle.

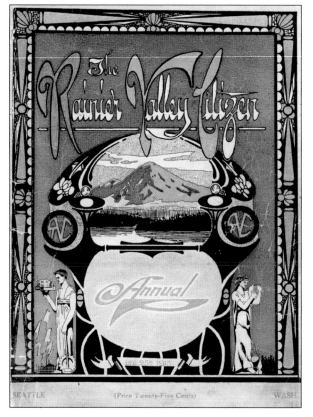

To celebrate the close of the eighth year of continuous publication of the *Rainier Valley Citizen*, the *Citizen's* Christmas annual was issued as a supplement to the December 25, 1915, issue of the newspaper. The booklet touted "the splendid advantages" possessed by the district. Mount Rainier rises behind Seward Park and Lake Washington, with representations of industry (male) and artistry (female).

Three

GOOD TIMES AND BAD

Like the rest of the country, the Rainier Valley faced the challenges brought on by the Great Depression, World War II, and resulting demographic changes. The hard times of the early 1930s made self-help a virtue. The Rainier Valley was at the forefront of activities organized by the Unemployed Citizens League, which organized a barter economy for food and fuel. Columbia City was the site of the first breadline in the city. The small groceries and businesses that were the heart of the valley struggled to survive.

Transportation underwent radical change during this period, as the citizenry, fed up with the delays, accidents, and fare hikes on the electric trolley, successfully lobbied for its demise. On New Year's Eve in 1936, the trolley made its last run; shortly thereafter, the rails were torn up and Rainier Avenue was turned over to cars and buses. In 1940, Interstate 90 sliced through the heart of Garlic Gulch in North Rainier and tunneled through the Mount Baker neighborhood to reach Lake Washington and the first floating bridge.

World War II brought an influx of defense workers from around the county to the Boeing plants along the Duwamish River. Many diverse families settled in nearby Rainier Valley, particularly in the Holly Park and Rainier Vista housing projects built for them along Empire Way. The exceptions were the Japanese families who had recently settled in the north end of the valley, as well as those who had been long established in the south end—nearly all were abruptly relocated to internment camps in 1942. Few returned.

After the war, Holly Park and Rainier Vista were converted to permanent public housing projects for returning veterans and others. Growing population in the city pushed many families south where housing was more affordable and there were fewer racial covenants to keep them out.

A number of Rainier Valley's enduring businesses were founded during this time, including Oberto's Sausage Company, Borracchini's Italian Bakery, Stewart Lumber & Hardware, Kusak Cut Glass Works, Darigold, Inc., and Chubby & Tubby, a war surplus shop turned hardware store. The nursery that was to become the world-renowned Kubota Garden was founded in 1923.

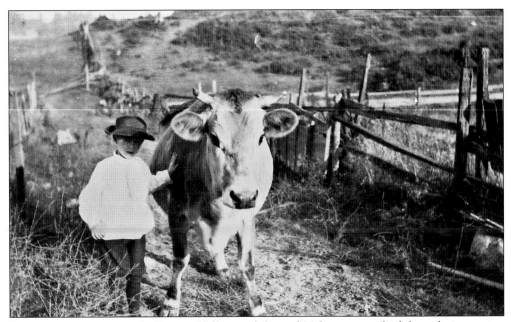

Farming was common in the Rainier Valley until the mid-20th century, which brought increasing pressure to develop farmland for housing. From early settlement days through the Depression, people strived to be self sufficient by gardening and keeping small farms. Some grew enough to sell at roadside stands or at the Pike Place Public Market in downtown Seattle. Here, young Judd Hines tends his cow on his family's North Rainier farm in about 1920.

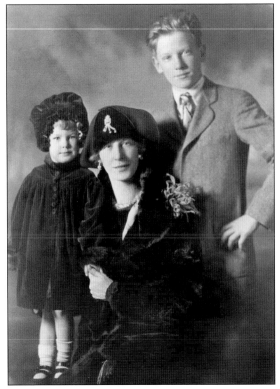

The second generation of the Hausler family poses for a studio portrait in 1925. Louise and Rhineholt Hausler opened their first one-room grocery store in 1901 near Hillman City, financed by the pawning of Louise's wedding ring for $100. The family's business success can be seen in the finery of their daughter Tillie Stevens and her children, Jack and Roseanne. In 1938, Jack Stevens engraved the bonds that kept the Lake Washington Floating Bridge afloat.

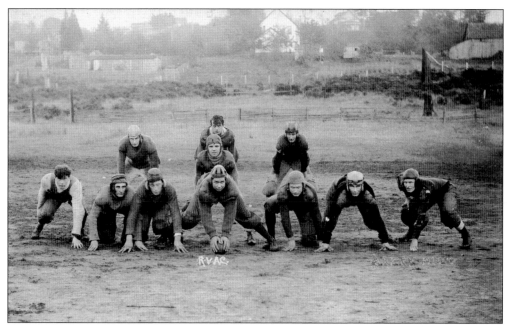

A group of football players form the line of scrimmage in 1920. The Rainier Valley Athletic Club was organized for sports enthusiasts in 1908 and acquired sponsorship from local businesses to compete with other districts in Seattle. Second from the left in this photograph is Pierre Weiss, future owner of Columbia Motor Works on Ferdinand Street.

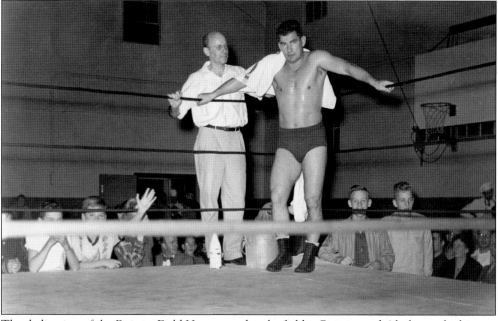

The dedication of the Rainier Field House, on the playfield at Rainier and Alaska, took place on September 20, 1928. It featured children's sports, a Boy Scout band concert, opening of a "Mystery Trunk," and the "All City Prize Waltz" (grand prize was $25). The Field House was home to dances, kite flying, and other sporting events, such as this 1950s-era Lions Club wrestling fundraiser. (Courtesy of the Seattle-Rainier Lions Club.)

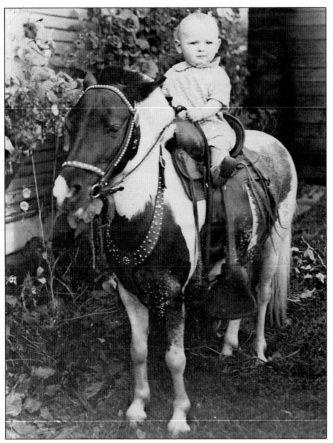

Eight-month-old Richard Ratzloff poses precariously on the back of a small pony in 1937. It was the fashion for many years to pose young children with animals. Richard's grandparents had a farm on the east slope of Beacon Hill, where Dearborn Park is today.

Columbia Undertaking on the corner of Rainier Avenue and South Alaska Street is pictured here around 1921. The structure, first built in 1906 as a single-family dwelling, was eventually expanded to become a mortuary. Before expansion, it was the boyhood home of Leo Lassen, famed baseball announcer for the Seattle Rainiers. This building stands today as Columbia Funeral Home and Crematory.

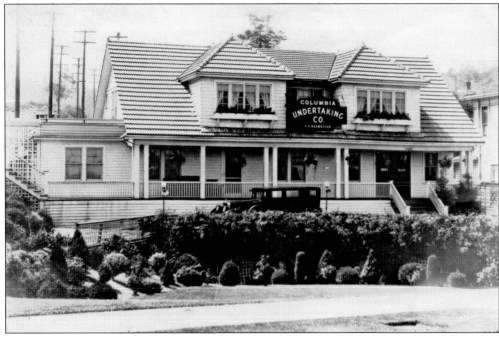

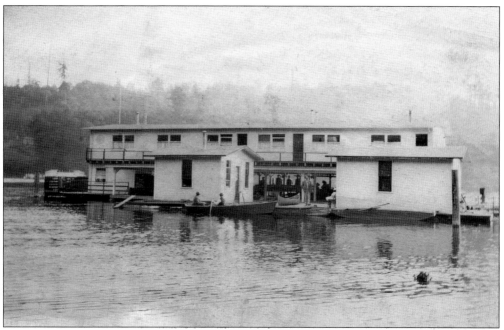

Before the Seattle, Renton & Southern Railway line was extended to Renton, O'Hara's Store and Boathouse served as the end of the line. The store and popular picnic spot at Rainier Beach is pictured here in 1920. Day-trippers could climb aboard the streetcar with lunch and a blanket to spend the day swimming or fishing at Rainier Beach.

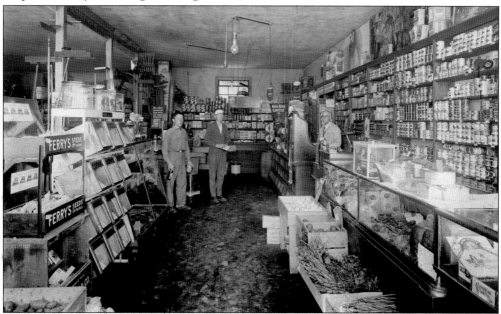

The Rainier Beach Grocery was located at the Rainier Beach Station on the corner of Rainier Avenue and 57th Avenue. In the 1920s, small businesses and groceries multiplied along the rail route. William Hutchinson, the young employee on the left, grew up in Rainier Beach, attended Franklin High, and went on to become a prominent surgeon. He founded the Fred Hutchinson Cancer Research Center, named for his famed baseball-playing brother.

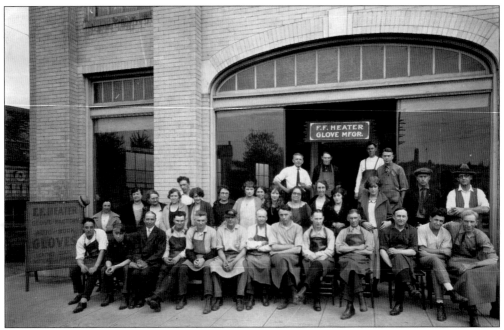

In this photograph, employees of the Heater Glove Company at 4812 Rainier Avenue take a break in front of the factory located on the ground floor of the Ark Masonic Lodge. In addition to gloves, Heater Glove manufactured other leather products. Most notably, the company made an aviator helmet worn by Charles Lindbergh during his historic transatlantic flight, as well as boxing gloves worn by Jack Dempsey and local pugilists.

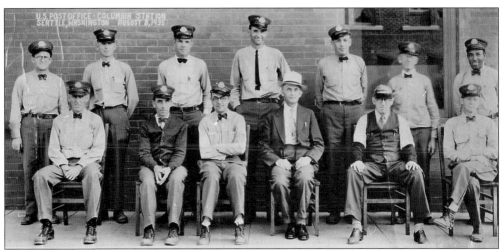

Columbia Station, the main post office serving the Rainier Valley, has moved at least eight times over the decades. Taken on August 8, 1935, this photograph depicts postal workers at the Hudson Street location. Typically, in the early days, the station was co-located with other businesses.

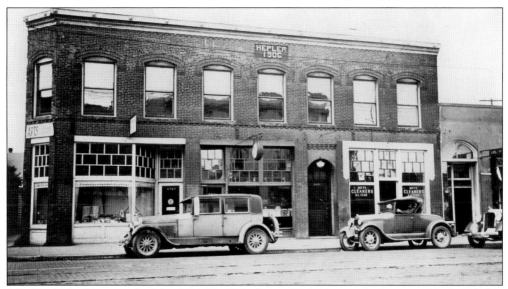

The Hepler building was built by C.R. "Ras" Hepler in 1906. Prior to construction, Hepler's father had built a grocery store a block north. The upper floors of the new brick building housed doctors' and dentists' offices and, at one point, served as the Hotel Hepler. Over the years, the building has housed a movie theater, a meat market, and the post office.

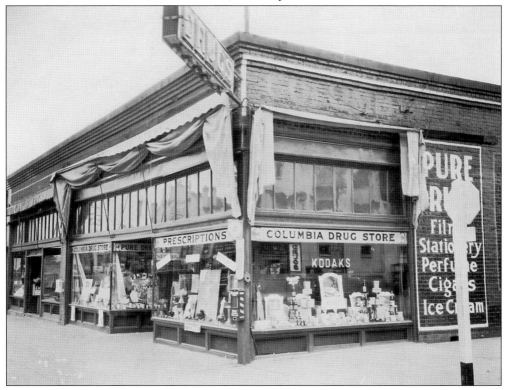

Many drugstores and small groceries served the growing communities along the Rainier Valley. Columbia Drug Store, located at 4872 Rainier Avenue, had an ornate marble soda fountain counter with a Tiffany lamp.

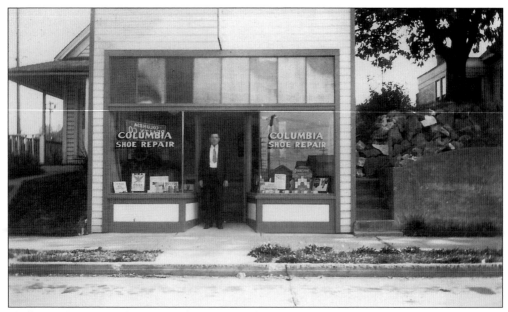

Phillip and Anna Paskan arrived in Seattle shortly before the Depression with four young daughters. Croatian-born Phillip worked for the Works Progress Administration while Anna found employment at a laundry. A shoemaker by trade, Phillip was able to repair shoes in the evening until they could afford to set up shop in a storefront addition. The Columbia Shoe Repair was in operation until the late 1950s.

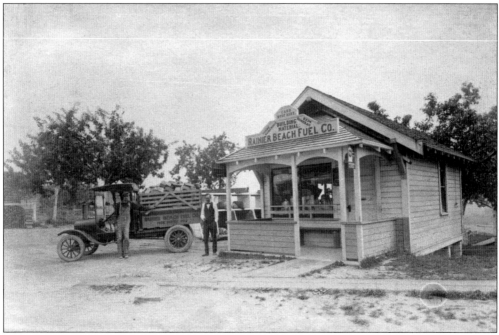

The Rainier Beach Fuel Company, owned by Ralph Nichols, was located in Rainier Beach. Part of the sign on the building that reads "Cars Stop Here" refers to the store's function as a trolley stop. Covered benches were available for passengers. The fuel company delivered coal and perhaps wood, as well as ice in the summer.

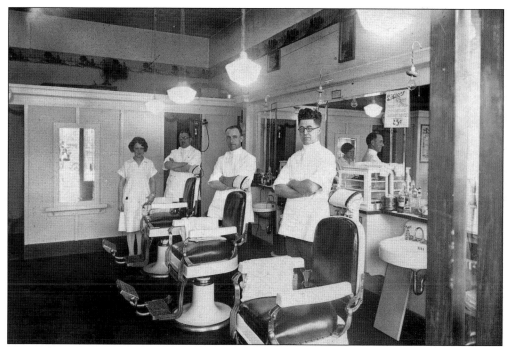

Pictured in the mid-1920s, Menzo LaPorte owned this barbershop at 4910 Rainier Avenue. It was thought the finest ever to grace the Rainier Valley. Catherine's Beauty Shop, located in the back, was owned by local Catherine Brassington, standing at the far left. The alert reader will spot LaPorte on the right.

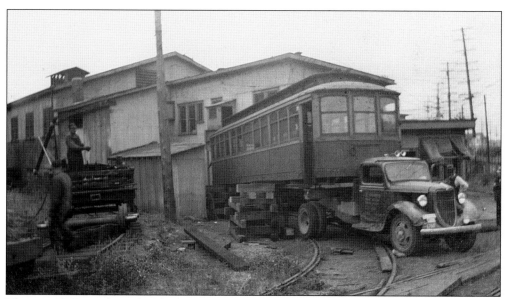

The year 1937 was the end of the line for streetcars in the valley. The cars were hauled away to be scrapped, and the Hudson Street car barns were razed and left in rubble, prompting the *Rainier District Times* to exhort Seattle mayor Arthur Langlie that "the old barns . . . might contribute to the injury and possible moral delinquency of some of our children."

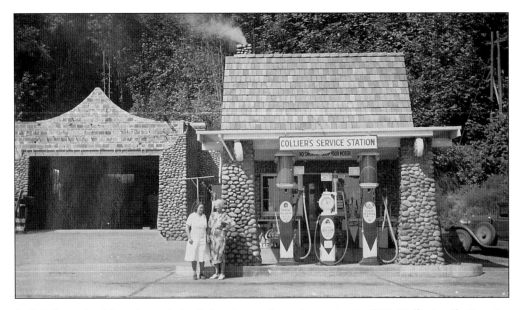

Earl Collier, a bricklayer by trade, built this river rock service station in 1926. Collier's wife, Beatrice Collier, and Tina Beckworth stand in front of the pumps in 1935. Collier's Service Station is still a landmark on Rainier Avenue south of Rainier Beach. Below, Collier's can be seen on the left in this 1936 photograph of the Renton-bound streetcar on one of its last runs. Hopes that the rail line would one day be extended farther south, perhaps to Puyallup, were never realized. This idea was the "southern" part of Seattle, Renton & Southern Railroad.

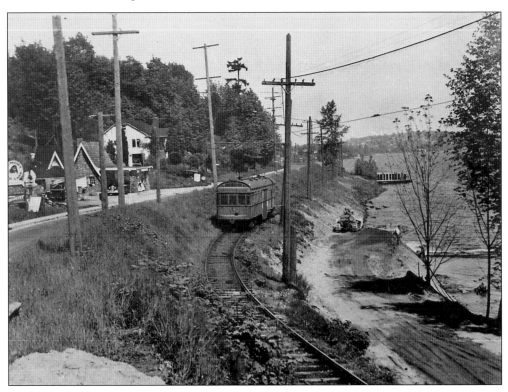

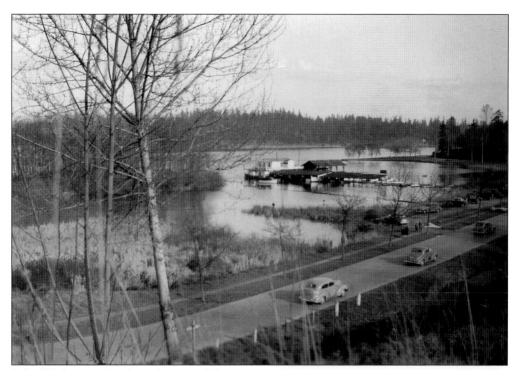

Lake Washington Boulevard is one of the most photographed scenic drives in Seattle. Pictured above is the Olmsted Brothers–designed parkway heading south toward the Lakewood Boathouse and Seward Park in 1928. Ohler Island, once a wild bird sanctuary, is visible on the left. Today, there is a new boathouse and marina; a dock connects the mainland to the island. The Olmsted Brothers park plan for Seattle incorporated Seward Park into the "emerald necklace" of parkways that connected the park with the Washington Park Arboretum and Woodland Park to the north, and Jefferson Park to the west. At right, Philip Weiss enjoys a stroll in beautiful Seward Park around 1930.

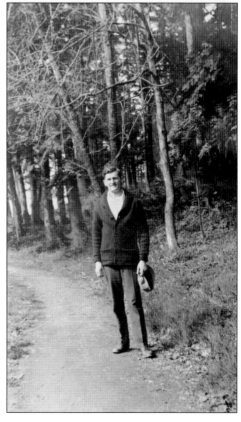

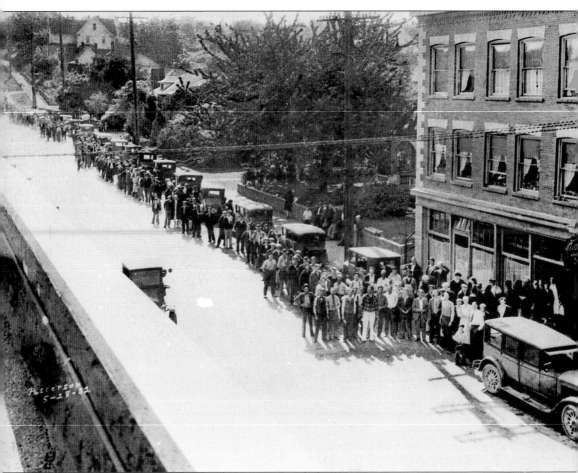

This line of people in front of the Toby Building on Edmunds Street in Columbia City waits for bread and other food during the Great Depression. The 1932 relief station, the first in Seattle, was run by the Unemployed Citizens League (UCL), a self-help organization that also delivered firewood to families in need. The UCL, which had loose ties with the communist party, helped fill a need while the local authorities debated what action to take. Poverty was a reality for many Rainier Valley families during this period. James O. Johnson recalled the time his family was down to its last nickel: "We didn't have nothing to eat for three days until the neighbors took pity on us." Belt tightening learned in the Depression served well during the rationing days to come during World War II.

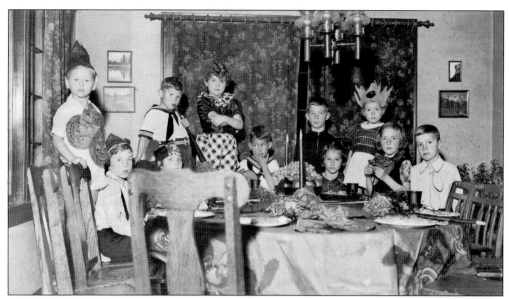

In the image above, young Robin and Stuart Weiss entertain their friends at a 1935 Halloween party in their Seward Park area home; at right, with sweaters over their sailor suits, they find that a three-wheeler will accommodate two. Four-year-old Robin rides behind nearly six-year-old Stuart. The Weiss family was prominent in the community. The boys' father, Philip, was an attorney, and his brother, Pierre, owned and operated Columbia Motor Company in Columbia City. Their mother, Marion Southard Weiss, was trained as a social worker and served on a number of boards after her marriage (See page 102). The family was more fortunate than many during the Depression.

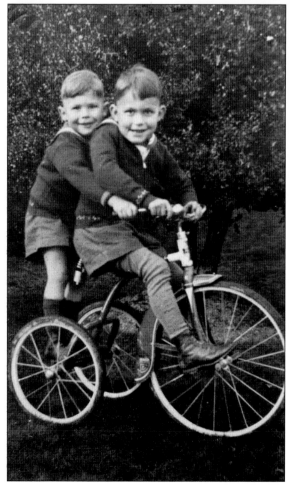

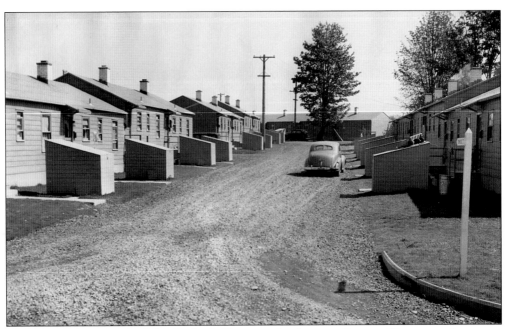

During World War II, the federally funded housing development Rainier Vista, seen above, was constructed for Boeing workers who came from all over the country to support the war effort. To alleviate overcrowding at the nearby Columbia School, the federal government also built an annex called Rainier Vista School (below) in 1943. The school offered early grades for baby boomers until 1971. Since that time, it has been used by the school district for special programs such as the Head Start school readiness program and the Interagency Academy, a program for youths having difficulty within a traditional school setting. (Both, courtesy of the Seattle Housing Authority.)

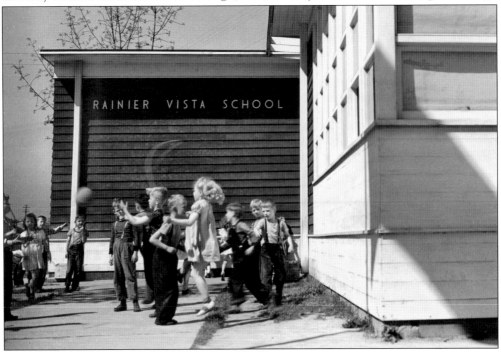

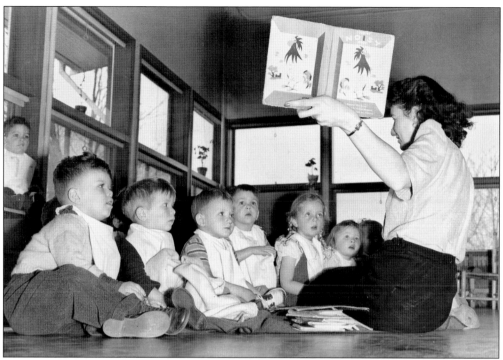

The Holly Park housing project opened in 1942 on the south slope of Beacon Hill. Like Rainier Vista, it was built originally to house defense workers. After the war, both communities were converted to serve families and individuals in need. Above, a preschool teacher reads to her students at the Holly Park Nursery School in 1948. Below, in the more affluent Lakewood neighborhood, Pearl Piper ran a popular private preschool from 1917 to 1953. (Above, courtesy of the Seattle Housing Authority.)

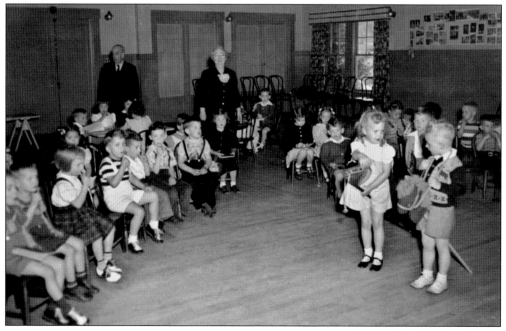

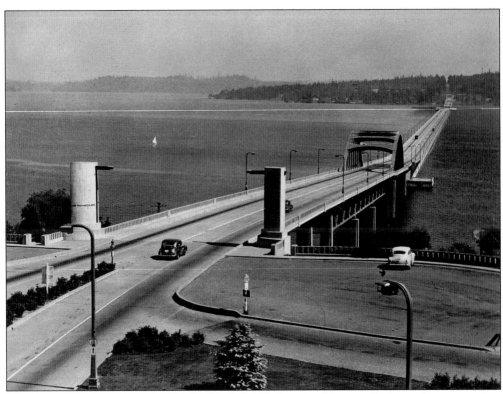

Beginning in 1939, construction of the first Lake Washington Floating Bridge and its approaches sliced through the heart of Rainier Valley's Garlic Gulch. At the time, it was the world's largest floating bridge. The above photograph was taken shortly after the bridge opened to traffic on July 2, 1940. In the early 1950s, the construction of elevated viaducts, below, sealed the fate of the neighborhood and many of its institutions. The old Colman School, which operated from 1909 to 1985, can be seen on the crest of the hill to the right. After closure by the school district, the building was occupied for eight years by activists urging its use as an African American museum. This dream came to fruition in 2008 with the birth of the Northwest African American Museum. (Above, courtesy of Mount Baker Community Center.)

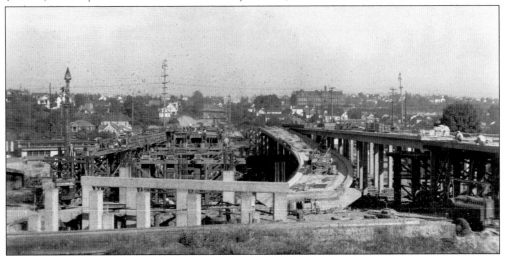

Four

THE CHANGING FACE
OF THE VALLEY

After the optimism of the postwar years, the Rainier Valley fell on hard times during the 1970s and 1980s due to the Boeing Bust and resulting economic recession in Seattle, as well as a growing drug culture among urban youth. Parts of the valley earned a lingering reputation for crime and gang activity. Despite public and private efforts to revitalize sections of the valley, stretches of both the Rainier Avenue and Martin Luther King Jr. (MLK) Way corridors bear the evidence of repeated boom and bust cycles.

In 1978, the federal government designated Columbia City as a national register district, and the City of Seattle followed suit by making the neighborhood a local landmark district. Spurred by these twin honors, the city and local merchants mobilized to refurbish the area, restoring historic buildings and sprucing up sidewalks to create an attractive, walkable community. A number of historic churches and lodges have found new uses as community gathering places.

During the same period, the US Department of Housing and Urban Development and the Seattle Housing Authority committed to replace the deteriorating housing projects of Rainier Vista and Holly Park with new, mixed-income communities. The city dedicated many resources to projects along MLK Way, and, in 2009, a long-anticipated light rail project went in, transforming this blighted and largely avoided street into a bustling transportation and commercial corridor.

Communities throughout the valley have benefitted from the restoration or repurposing of historic structures. Franklin High School, which was to be torn down, was saved by community effort. A Tudor-style parks building in Seward Park was converted to an environmental center, and Colman School, located at the head of the valley, is now a museum dedicated to African American history and culture. Kubota Garden, a target for housing developers, became a city landmark in 1981, and the old Empire Bowling Alley in the Othello neighborhood found new life as the Filipino Community Center.

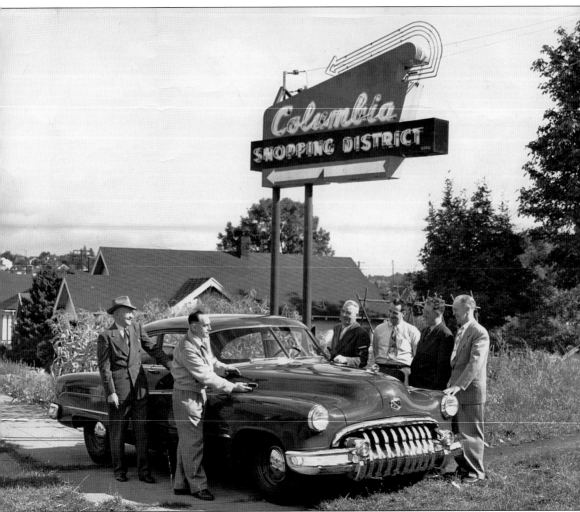

By 1950, automobiles were the desired mode of transportation. Whereas most Rainier Valley residents had done their shopping close to home by necessity, they could now easily travel to other parts of the city for great deals—even to the newly opened Northgate Shopping Mall at the north end of town. Columbia City merchants decided to capitalize on the lure of the automobile to encourage residents to shop locally. For a limited time, shoppers earned lottery tickets by purchasing goods from local merchants, and the grand prize was this 1950 Buick two-door Sedanette. The paper reported that the young man who won the car took the microphone and asked, "Who wants to buy the old klunk I've been driving around?" Admiring the car are, from left to right, Arthur Anderson, Grayson & Brown Furniture and Hardware; Hy Funk, Columbia Food Center; C.W. Wedin, Columbia Realty Company; Jay Jacox, Halverson's 10-cent Store; Menzo LaPorte, Rainier Valley Barber; and Russ Vold, Northwest Appliance Sales and Service.

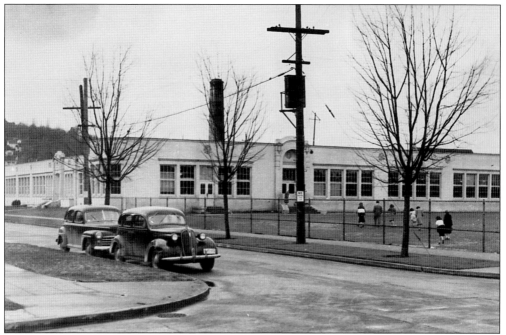

By 1951, the year this photograph was taken, automobiles dictated development in the valley. The second Columbia School, built in 1923, was designed in the popular Mission Revival style by noted architect Floyd Naramore, who is credited with designing a number of Seattle schools in the 1920s, including Garfield High, Roosevelt High, and an expansion of Franklin High.

Business boomed during the 1950s. The postwar era brought an emphasis on comfort and convenience in the home after the privations of the Depression and war decades. Grayson & Brown Furniture and Hardware in Columbia City expanded its offerings to include electric appliances.

Founded in 1946 in a surplus Quonset hut, Chubby & Tubby grew into a Seattle institution, with three locations offering bargains in hardware, housewares, and garden supplies. Their famous Christmas trees sold for 97¢ in the early years and were still a bargain at the time the business closed in 2003. Grunge musician Kurt Cobain shopped for flannel shirts at the Rainier Avenue flagship store. Musician Dave Matthews was also a fan. Below, Chubby & Tubby, also known as Irv Friese (right) and Woody Auge (left), clown around in their office around 1985. Today, a new mixed-use building, which includes affordable housing, stands on the site.

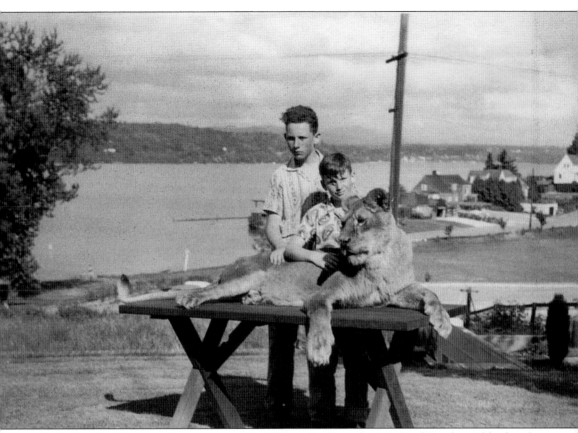

"Little Tyke," a 350-pound lioness, visited the Gibbon family in the Pritchard Beach neighborhood in 1955. A local celebrity, Little Tyke had been rescued from her violent mother at birth and raised by the Westbeau family near Auburn. Because she refused to eat meat, Little Tyke was adopted as an icon of the vegetarian movement. Gary Gibbon (left) and David Church pose with Little Tyke above Pritchard Beach drive. Gibbon recalls introducing his cat to the larger feline: "I took my cat 'Valley' over to see the lioness as she drank out of our birdbath, but Valley dug her claws into my arm and jumped away. Before they left, the owners got Little Tyke to roar by honking the horn on their truck. The lioness roared loudly and clawed deep grooves in our pear tree that we could show off for years to come. The loud roar brought neighbors to our fence to see what was going on. It was wonderful."

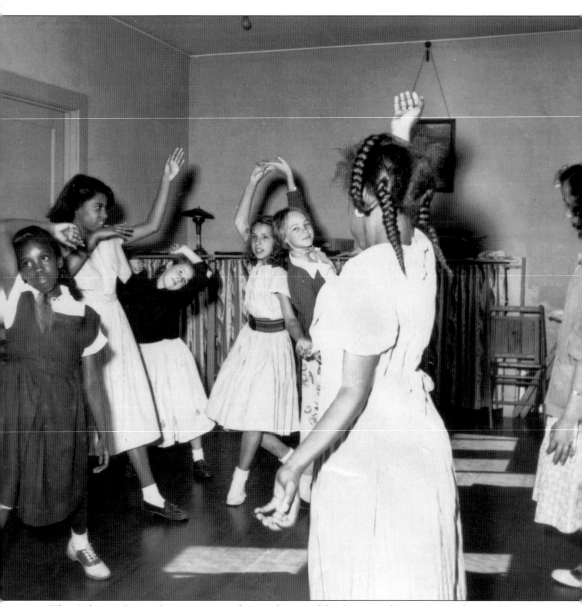

The Atlantic Street Center is one of several venerable charities that serve residents of Rainier Valley. Established as a settlement house serving Italians in North Rainier in 1910, it grew into a multiservice center focusing on youth and families of all ethnicities. A 1955 schedule offers modern dance, adult sewing, playschool, summer day camp, Boy Scouts, Camp Fire Girls, teenage nights, and boys' and girls' choruses. The center's original 1927 Italianate building on South Atlantic Street is still used for offices. Neighborhood House and Wellspring Family Services also boast a century of service in the valley. The former began as a Jewish settlement house, and the latter grew out of the Bureau of Associated Charities, the first effort to coordinate charitable work in Seattle. Younger groups serve the new immigrant communities. Asian Counseling and Referral Service, the Refugee Women's Alliance, and the Boys and Girls Club have built new service centers along once-blighted Martin Luther King Jr. Way. The Boy Scouts Chief Seattle Council is headquartered in a 50-year-old Rainier Avenue building. (Courtesy of Atlantic Street Center.)

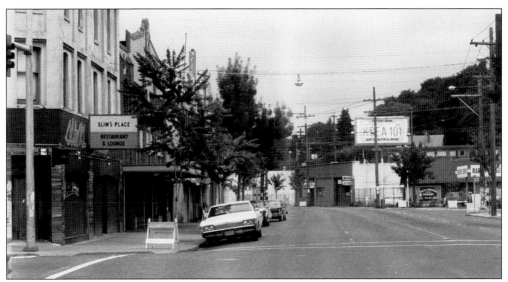

The postwar boom gave way to more troubled times in the 1970s and 1980s. The Boeing Bust and economic recession led to empty storefronts, increased crime and vandalism, and widespread neglect of historical landmarks. As seen in the image above, much of the valley's main thoroughfares resembled dumpy strips. After Columbia City was designated a historical landmark district in 1978, the city and merchants worked together to revitalize the area. The 1980 photograph below documents the ground-breaking ceremony for a project to widen sidewalks, add benches and trees, improve landscaping, and update traffic signals along Rainier Avenue. Pictured from left to right are state senator Ruthe Ridder, city councilman George Benson, state representatives John O'Brien and Gene Lux, Columbia City Merchants president Buzz Anderson, US congressman Mike Lowry, Rainier District queen Dee Dee Goodson, and Rainier District princess Eleanor Mitchell. (Below, photograph by Denis Law.)

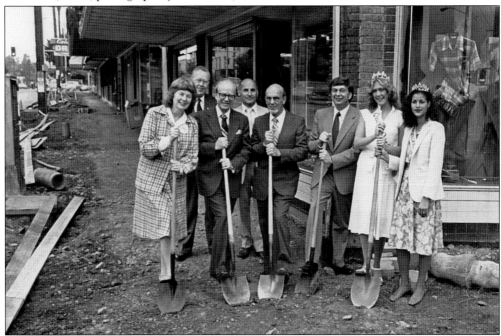

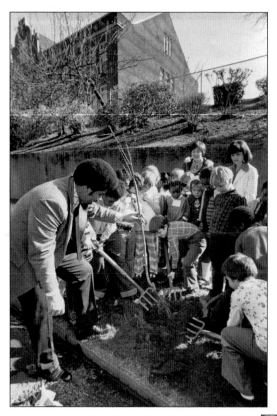

The ecology movement of the 1960s and 1970s touched the valley. In 1968, the city finally transformed the Genesee Dump, the former Wetmore Slough, into a park and playfield. Street trees were planted along parts of Rainier Avenue. In 1977, Othello Playground opened, bringing much needed green space to the heart of the valley. Here, students at the old Hawthorne School plant a tree in 1975.

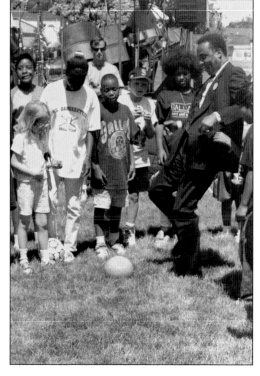

The Seattle Housing Authority worked hard to make the old wartime housing of the valley comfortable, affordable housing for low-income families, including new waves of immigrants from Africa and East Asia. Economic hard times, however, earned Rainier Vista and Holly Park reputations as undesirable pockets of poverty. In this 1993 photograph, Seattle mayor Norm Rice kicks off summer games with the children of Rainier Vista. (Courtesy of the Seattle Housing Authority.)

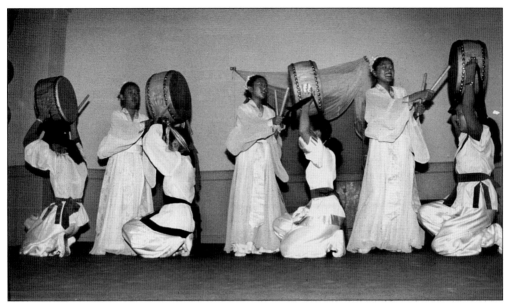

SouthEast Effective Development (SEED) was founded in 1975 with the purpose of revitalizing the Rainier Valley through economic development, affordable housing, and the arts. Among many projects, SEED helped preserve the 1926 Christian Scientist Church building in Columbia Park. Today, the Greek Revival building is home to SEEDArts and cultural performances such as this 1996 Korean dance show. (Courtesy of SEED.)

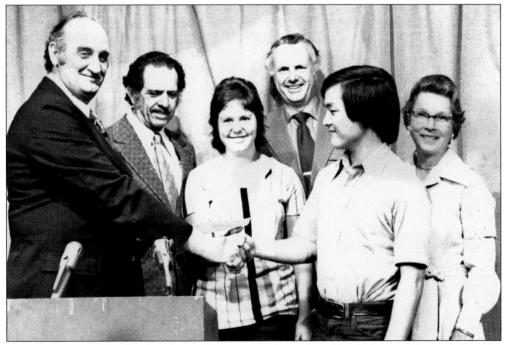

Rainier Beach High School students Chris Brewer (center) and Jon Takamoto (second from the right) receive awards from the Seattle-Rainier Lions Club in 1975 for their work with the school's cultural exchange club. The school opened in 1960 as a combined junior and senior high school. The younger students moved out a decade later. (Courtesy of the Seattle-Rainier Lions Club.)

Several North Rainier institutions have survived the boom and bust cycles. Borracchini's Bakery, Seattle's premier Italian bakery and delicatessen, was founded in 1922 and continues to attract buyers from all over the region to its Italian villa–style store. Remo Borracchini remembers growing up in his father's bakery: "My father made strictly Italian bread. He would make the bread in the afternoons, and then bake it in the evening, and then go out and deliver it in the morning. Every day. Seven days a week. My job after school was to load the brick oven with wood." Oberto Sausage Company, founded first in Seattle's International District in 1919, opened its North Rainier factory and retail shop a few years later. The Yoshimura family has owned and operated Mutual Fish, below, since 1947. (Below, photograph by Joshua Reese; both courtesy of Youth in Focus.)

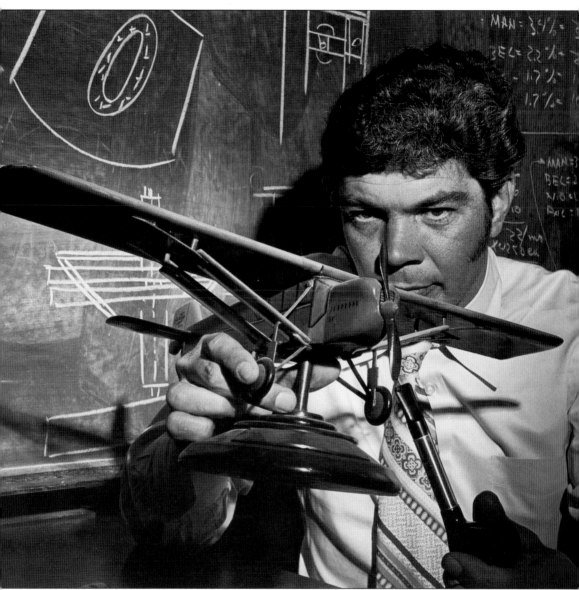

Industry and manufacturing have also been a part of the Rainier Valley. Pepsi has had a bottling plant for decades on Rainier Avenue, located a few blocks north of the Darigold milk processing plant. The 1914 Black Bear clothing factory in North Rainier is now Darigold's administrative headquarters. Liberty Sidecars found a showroom in a 1925 sheet metal factory. At the south end of the valley, Raisbeck Engineering designs and builds components that improve the performance and safety of aircraft. In this 1969 photograph, James Raisbeck studies the propeller design of the old Curtiss-Robin monoplane. The scribblings on the blackboard behind him show the result of studies to improve airflow over the aircraft. Today, the company manufactures Hartzell/Raisbeck Quiet Turbofan Propellers, or as they are now known, Raisbeck Power Props, first introduced in 1985. (Courtesy of James Raisbeck.)

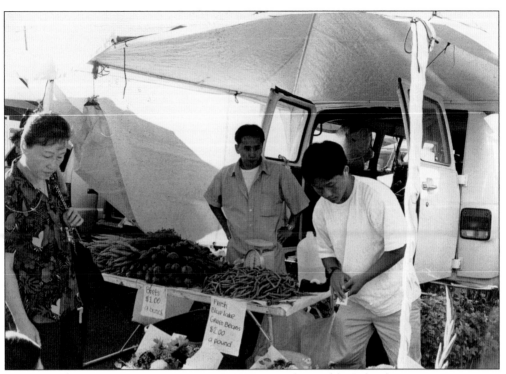

The weekly Columbia City Farmers Market, established in 1998, draws shoppers from all over the valley for fresh produce, flowers, baked goods, and ice cream. In 2010, it was recognized by CNN Travel as one of America's best farmers markets for travelers. (Courtesy of Youth in Focus.)

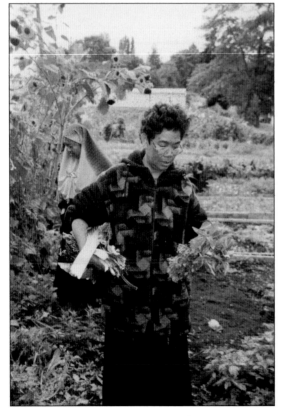

By the beginning of the 21st century, Rainier Valley was a far different place than it was a hundred years before. Large groups of immigrants from every corner of the world have created a rich, vibrant, and diverse culture. Asian immigrants, such as this Cambodian woman, and others have applied gardening skills to the community gardens at Rainier Vista and New Holly. (Photograph by Jyoti Gustafson, courtesy of Youth in Focus.)

The Rainier Valley experienced a large influx of refugees from East Asia during the 1970s and 1980s. The new immigrants brought their faith traditions with them, and today, the community includes a variety of Buddhist temples and Asian Christian churches. This Buddha greets visitors to the Wat Lao Dhammacetiyarom, a Laotian Theravada Buddhist temple on Martin Luther King Jr. Way.

Refugees from East Africa—both Muslims and Christians—arrived in the valley in large numbers in the 1980s and 1990s, bringing along their culinary traditions. Many shops and cafes offer halal foods, those permissible under Islamic law. Here a woman conducts the Ethiopian coffee ceremony at Fasica Restaurant in Columbia City. (Photograph by Annie Farmer, courtesy of Youth in Focus.)

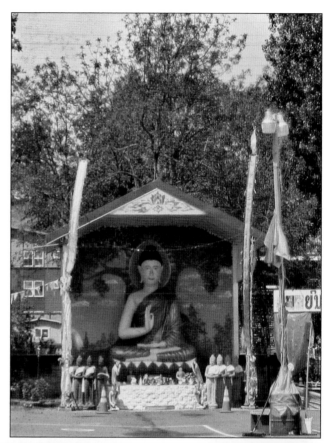

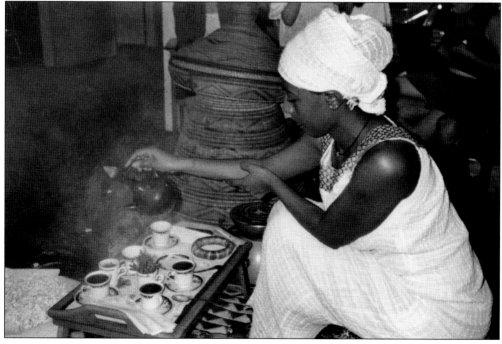

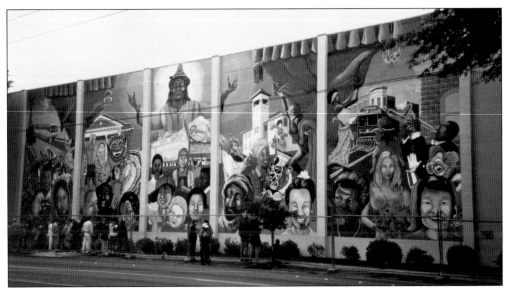

Rapid cultural change and revitalization efforts in the last decades of the 20th century brought public art to the community, much of it sponsored by SEED. In 1998, SEEDArts unveiled *Rainbow Valley*, a brightly colored mural painted on the side of the Darigold milk processing plant on Rainier Avenue.

The Hispanic/Latino community makes up a smaller, but significant, segment of Rainier Valley residents. Consejo Counseling and Referral Service has worked with Spanish-speaking families from the valley and beyond for 30 years. Its Angeline Street building is splashed inside and out with colorful murals celebrating Hispanic culture.

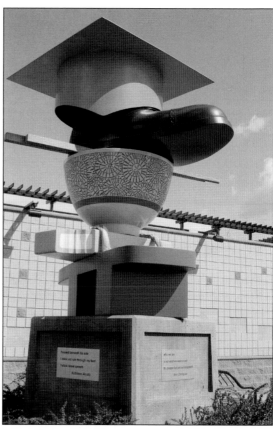

Some 73 years after the demise of the electric trolley, mass transportation arrived in the valley again in the form of Seattle's Link Light Rail system. The high-speed commuter trains have spurred both economic development and public art along the Martin Luther King Jr. Way route. Roger Shimamura's *Rainier Valley Haiku* at the Othello Station merges Japanese and American symbols to create an eye-catching sculpture. The summer 2009 opening of Light Rail was greeted with great fanfare, not to mention commemorative stickers, such as that pictured below. (Above, courtesy of Alan Humphrey)

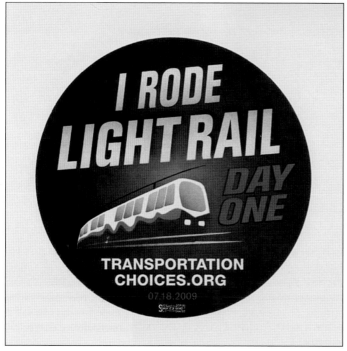

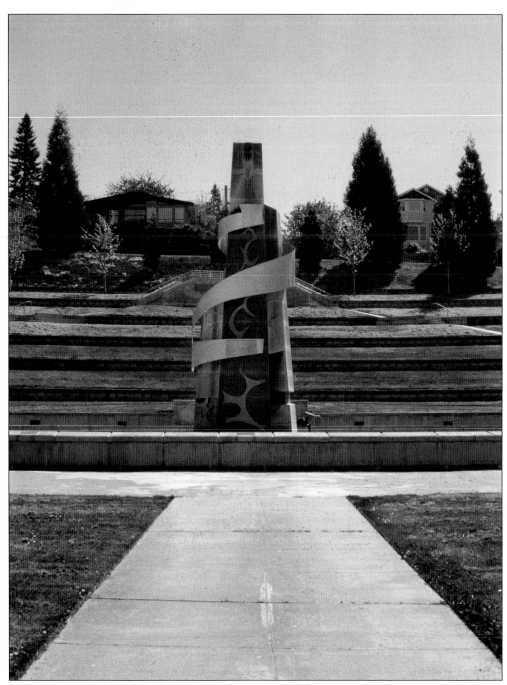

This memorial to Martin Luther King Jr., designed by Robert W. Kelly, stands in a public park at the head of the valley on the street renamed for the civil rights leader in 1982. The monolith recalls King's words "I've been to the mountaintop," spoken April 3, 1968, the day before his assassination in Memphis. Dedication was delayed several years due to lack of funding. An appropriation of $100,000 from the state legislature allowed the project to be finished in 1991. Although there is no record that Dr. King ever visited the Rainier Valley, his presence is strongly felt here. (Courtesy of Alan Humphrey.)

Five

A Tradition of Service

Rainier Valley has been and remains a home to many men and women serving their community in a variety of ways. As an incubator for many immigrant groups reaching Seattle, the valley has offered both problems to be solved and opportunities for homegrown leadership to tackle those problems. A surprising number of the state's political leaders began as valley residents, including two Washington state governors—Albert Rosellini and Gary Locke.

Others have found ways to serve the community through churches, service clubs, PTAs, and booster organizations. From the early days of settlement, fraternal organizations such as the Lions Club, the Freemasons, and the Knights of Pythias counted many notable men among their members, while ladies' clubs such as the Rainier Beach Women's Club took on both charitable and civic causes. Social clubs including the Lakewood-Seward Park Community Club, the Mount Baker Community Club, and the Royal Esquires have also shaped the valley. A number of major charities have made this community their home.

During the economic collapse of the 1970s, activist groups such as SouthEast Effective Development (SEED) and the South End Seattle Community Organization (SESCO) organized local citizens to fight to keep the best of their community. Their legacy of empowerment continues today. SEED has worked to create affordable housing, public art, and gathering spaces throughout the valley since 1975, including transforming the old Christian Scientist Church on Alaska Street into a cultural performance center. Although no longer active, SESCO was a major player in motivating valley residents to combat crime, neglect, and perceived apathy on the part of city hall.

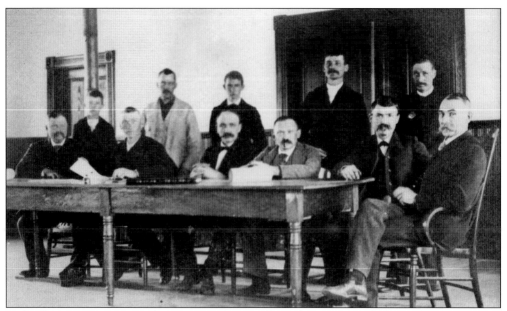

Columbia City incorporated in 1893, making it the only Rainier Valley community to do so officially. This fourth-class city had its own government for 14 years until it was annexed along with several other communities by the City of Seattle in 1907. In this 1893 photograph are the town fathers (and a few sons) gathered around a council table. Mayor C.P. Hutcheson is seated on the far right.

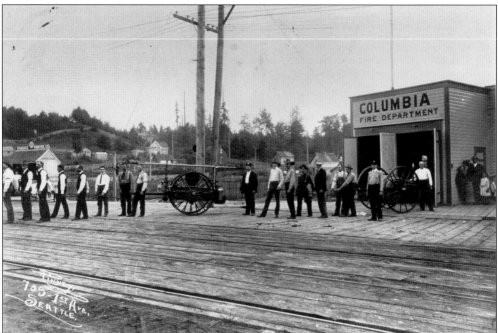

Columbia City Fire Department volunteers drill in front of the fire station adjacent to city hall. Equipment including a manual pumping cart and a hose reel cart had to be pulled to the scene by hand or horse, even uphill. Water mains were too small to serve fire hydrants. In 1901, fires were fought with chemical engines assisted by garden hoses and bucket brigades.

W.W. "Bill" Phalen was a two-time mayor of Columbia City in 1905 and 1907. He was the proprietor of W.W. Phalen, Your Grocer at 4863 Rainier Avenue. Phalen was three-time chair of the valley's first community festival, the Rainier Fiesta. He also organized the first fire company and baseball team in the valley.

The Modern Woodmen of America was founded by Joseph Root of Iowa in 1883. Promoting mutual self-help, in the spirit of the pioneer woodmen, the society continues to provide benevolence work at the local level, as well as scholarships and insurance plans. Members of the Woodmen drill team stand in 1907 in front of the Weed Building, which housed their meeting room, at 4904 Rainier Avenue.

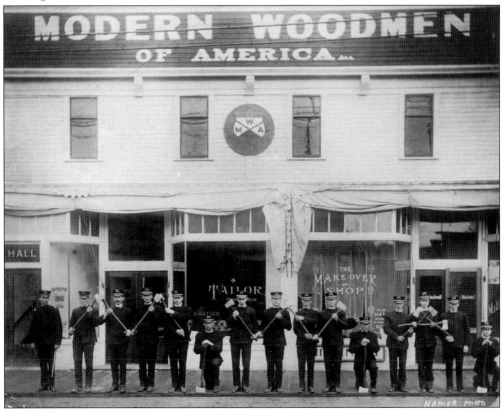

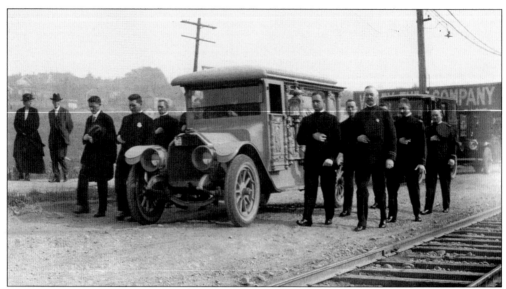

Seattle police detective James O'Brien immigrated to the Rainier Valley from Ireland in 1903. His family's home on Findlay Street in Hillman City was nearly finished when he and two other officers were fatally shot by bandit John Smith in downtown Seattle in 1921. His funeral procession left St. Edward Church and passed Findlay Street before moving slowly toward downtown Seattle, where thousands paid tribute to the three fallen officers. (Courtesy of O'Brien family.)

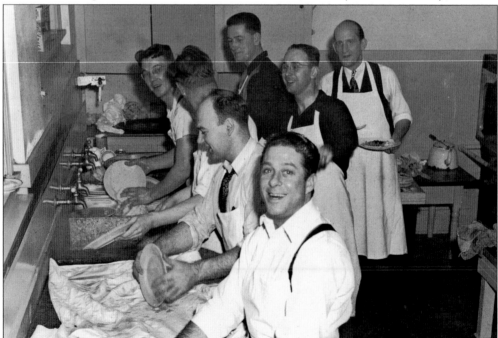

Seattle-Rainier Lions Club members wash dishes at the Rainier Playfield after a fundraising event. The Lions, an international service organization, were challenged by Helen Keller to become "Knights of the Blind," a rallying cry for Lions projects around the world. The Seattle-Rainier chapter, formed in 1937, operates out of the 1913 Rainier Valley Investment Company building in Columbia City.

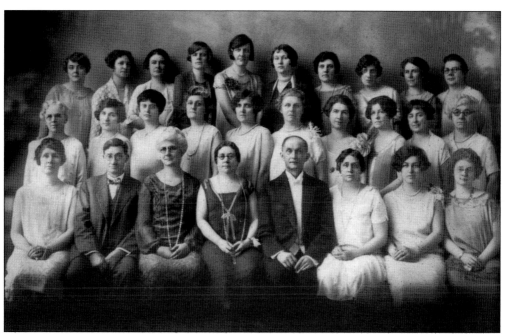

The Ark Lodge Masonic Temple is part of the long history of fraternal organizations in the valley. In 1903, Ark Lodge No. 126 of the Free and Accepted Masons held its first meeting at Fraternity Hall. Later, they constructed a beautiful building on Rainier Avenue. Officers of the lodge pose in 1921 with officers of the Order of the Eastern Star, an affiliated group that, unlike Masons proper, allows both men and women to join. The 1944 edition of the *Lodge By-Laws* is embossed with the traditional Masonic symbol, the square and compass, harkening back to the origins of Masons as builders.

Ark Lodge No. 126

Free and Accepted Masons of Washington

ARK TEMPLE
4816 Rainier Avenue
SEATTLE, WASH.

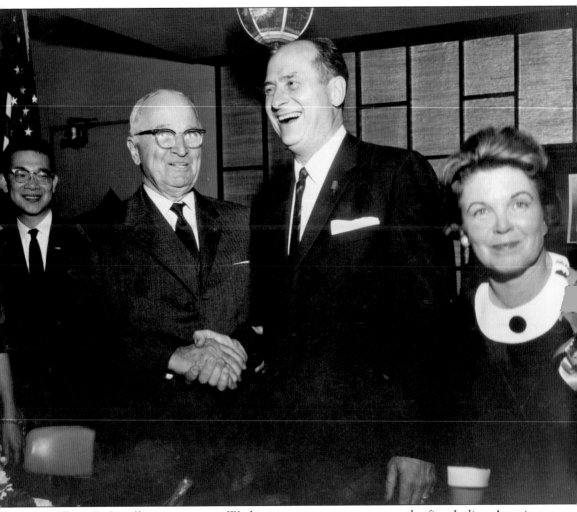

Albert D. Rosellini, a two-term Washington state governor, was the first Italian American Catholic governor elected west of the Mississippi. A New Deal Democrat, Rosellini first served the valley's 33rd district in the state senate from 1939 to 1957. His early activism in Garlic Gulch near his home in Mount Baker Park and leadership in the Rainier Business Men's Club supported his successful 40-year career in politics. As governor from 1957 to 1965, Rosellini facilitated the Seattle World Fair in 1962, advocated for the building of the State Route 520 floating bridge (which now bears his name), expanded the state highway system, reformed the state's prisons and mental health facilities, and created the University of Washington Medical School and Dental School. He and his wife, Ethel, were married at Our Lady of Mount Virgin Church and raised five children. Rosellini passed away in 2011 at the age of 101. Pictured here at a 1960 campaign fundraiser are, from left to right, assistant attorney general Wing Luke, former US president Harry S. Truman, and Albert and Ethel Rosellini. (Courtesy of O'Brien family.)

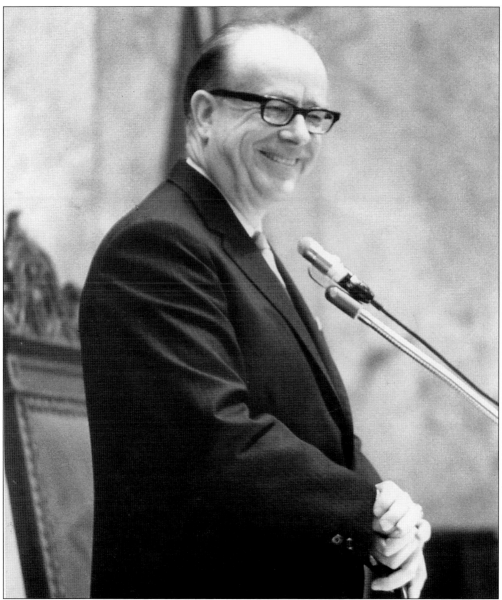

John L. O'Brien, four-term speaker of the state House of Representatives, represented the 33rd, 35th, and 37th legislative districts in Rainier Valley for 52 years. O'Brien was born in 1911 and lived in Hillman City and the Seward Park neighborhood for 95 years. Specific to the valley, O'Brien sponsored legislation to save Franklin High School from demolition, sponsored the cleaning up of Lake Washington and the building of a pedestrian park walkway along Beacon Avenue South, and secured funding for the replacement of the Lucile Street Bridge. He also passed legislation for the return of hydroplane racing to south Lake Washington and advocated for the conversion of the Genesee Street dump into Genesee Park. The valley remembers O'Brien for his leadership as chair of the Rainier District Pow Wow for 52 years, president of the Rainier Business Men's Club, and his involvement at St. Edward Church, where he and his wife, Mary, were married. Professionally, he was a certified public accountant and operated a heating oil company. (Courtesy of O'Brien family.)

Rainier Valley's civil defense met in the basement of barber Menzo LaPorte's home on 43rd Avenue. Air raid wardens, trained in civil disaster safety during World War II, monitored the required "shades down at dusk" rule, an effort to thwart possible enemy planes. Homes were equipped with five gallons of pump water, buckets of sand, and gas masks for fire and magnesium bomb protection.

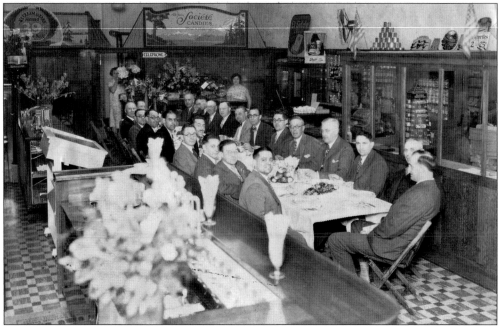

Rainier Business Men's Club originated in 1927 and continues today as the Rainier Chamber of Commerce. In this 1928 image, local notables meet at Nick Vamkros's Columbia Confectionery. It was a man's world until the 1960s, when the first women joined the chamber. Realtor Jean Vel Dyke was the first female president in 1973.

Sam Smith, with four of his six children, tallies votes on election night in his Seward Park home. Smith served the 37th district in the state's House of Representatives for five terms before becoming the first African American elected to the Seattle City Council. He served on the council for 24 years, 8 of those as president. (Courtesy of Smith family.)

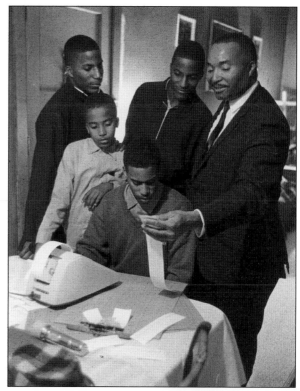

When Sam Smith left the House of Representatives for the city council, he mentored and encouraged George Fleming to run for his 37th district legislative seat. Fleming served one term in the house and then won the first senate seat in Washington state held by an African American. He served as vice chair of the Democratic caucus from 1973 to 1980 and as caucus chairman from 1980 to 1988. (Courtesy of George Fleming.)

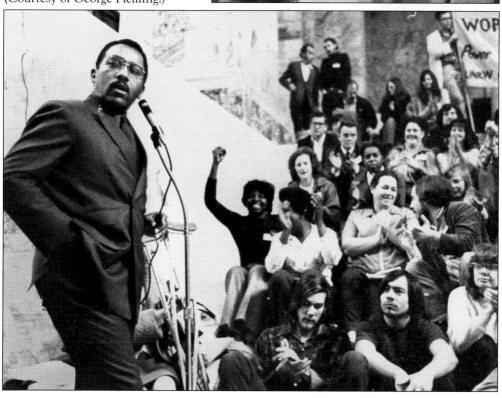

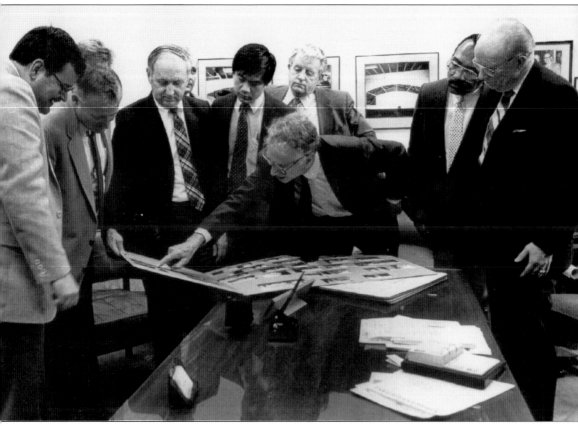

In 1986, 37th district legislators and community leaders rallied to save the 1912 Franklin High School building from demolition. Award-winning architect Fred Bassetti was hired to design the renovation. Bassetti, pointing, shows the plans to state school superintendent Buster Broilett (fourth from left), Franklin graduate representative and future governor Gary Locke (fifth from left), Sen. George Fleming (second from right), and project leader John L. O'Brien (far right), among others in Olympia. Locke rose through the political ranks from humble beginnings to become the first Asian American governor in the United States in 1996. Locke grew up on Beacon Hill, graduating from Franklin High School in 1968. He lived in the Seward Park neighborhood while serving as a state legislator for the 37th district from 1982 to 1994. In 2009, he was appointed US secretary of commerce by President Obama and confirmed as a US ambassador to China in 2011. (Courtesy of O'Brien family.)

A Rainier Boys' Club member receives a special award from board member Herb Tsuchiya (left) and the Rainier Boys' Club director. The original club in Rainier Valley, called the Rainier Vista Boys and Girls Club, opened in 1976. In November 2008, a new 40,000-square-foot club including a teen center, media room, gymnasium, technology lab, learning center, and game room opened its doors.

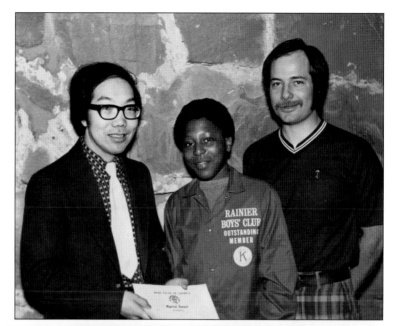

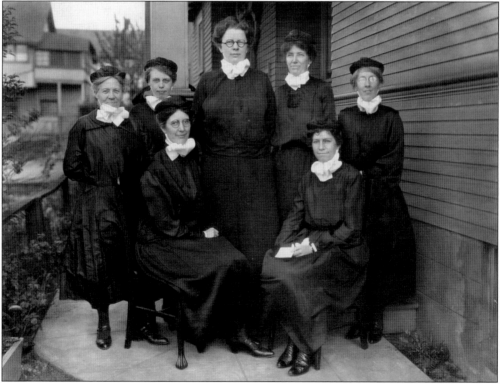

The Atlantic Street Center, a 100-year-old charity in North Rainier, was founded by a group of Methodist deaconesses, laywomen who are dedicated to volunteer work among the poor. These women wear the traditional garb of blue dress, white neck ruffle, and simple bonnet. They received professional training and did not marry. Today, deaconesses, while fewer in number, are free to marry and dress as they wish. (Courtesy of Atlantic Street Center.)

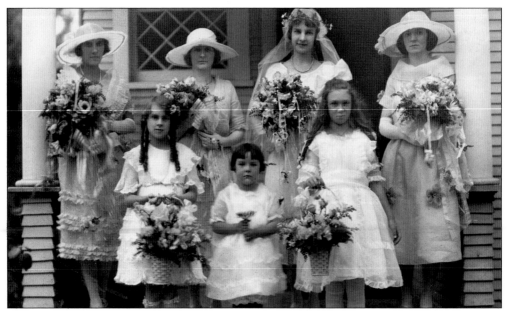

In 1891, Rev. U.C. Murphy organized a church congregation among the early pioneers of Columbia City. Free land for church buildings was included in the town's original plat. Columbia Congregational Church was constructed at 39th Avenue and Ferdinand Street for 20 charter members. The congregation relocated to the Lakewood neighborhood in the 1980s. Leora Brown (second row, second from right) married Arthur Anderson at the church in 1921.

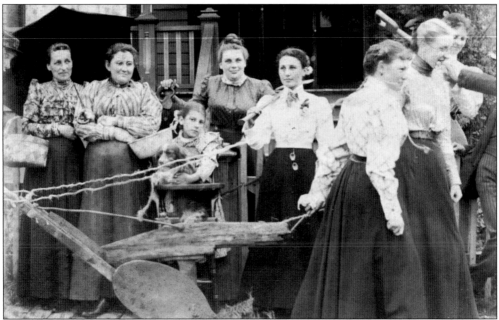

The Ladies' Aid Society of the Columbia Congregational Church plow at the home of Edith Brown in 1912. The society was first formed in 1892 with Mrs. Kelso as its first president. The work consisted of making quilts, basket socials, dinners, aiding hospitals, social work in the community, paying various church expenses, and hiring and paying a janitor. In the center of the back row is Leora Brown, the future Mrs. Arthur Anderson.

Henrietta McCloy, founder and first president of the Lakewood Civic Improvement Club, conceived the idea of selling stock for $5 a share to raise enough money to purchase land and building materials. In 1914, the organization built the first clubhouse owned completely by its membership in the city of Seattle. (Courtesy of Lakewood Seward Park Community Club.)

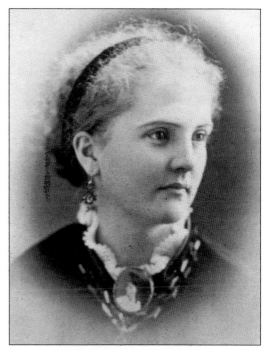

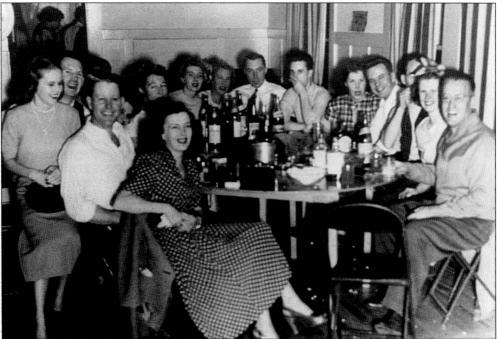

The years 1909 to 1914 marked the era for civic improvement clubs, as Rainier Beach, Beacon Hill, Mount Baker Park, Genesee, Atlantic Street, Lakewood, and Seward Park neighborhoods all established associations for the betterment of their neighborhoods. The Lakewood club successfully lobbied the city for three-plank sidewalks to accommodate baby carriages, the grading of Genesee Street, and shuttle streetcar service. There was also time for relaxation and socializing, as seen in this photograph of a 1950 Lakewood party.

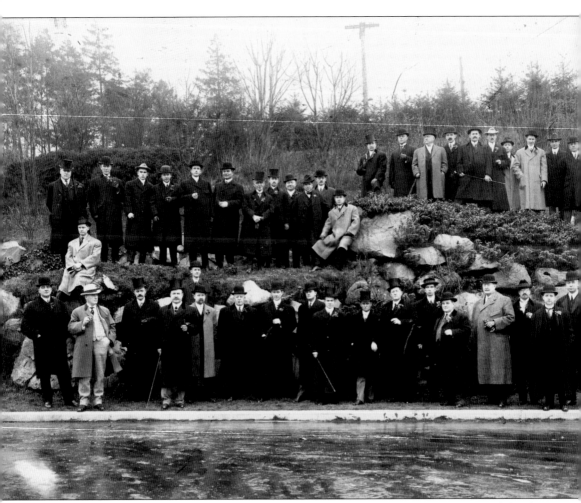

Mount Baker Community Club organized in 1909 as a social and civic improvement club. Their clubhouse, completed in 1914, held balls, masquerades, a bridge tournament, and an annual rose show. A favorite event in the early years was the New Year's Men's Day. All of the "Mixers, Good Fellows and Boosters" in the neighborhood would assemble at the clubhouse at 10:00 a.m., wearing top hats and dress clothes. They strolled down the streets, wishing neighbors a happy new year. Mount Baker Park was a planned community designed by the Hunter Improvement Company with the approval of the Olmsted Brothers. Winding streets and large plats were laid out with the deliberate intention of attracting wealthier families. Strict rules governed the type of residences that could be built. (Courtesy of Collins family.)

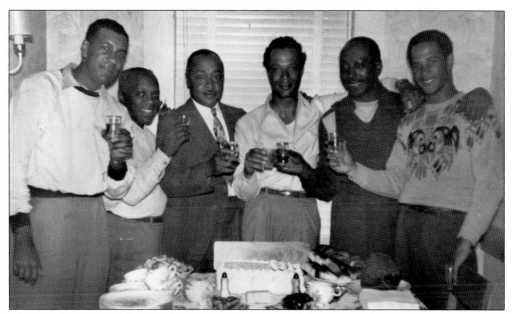

The Royal Esquire Club, an African American social club, was established in 1947 in Seattle's Central District. In 1986, the club moved to the Rainier Valley, where it remains a social and civic force, providing scholarships and financial support to youth programs. Some of the original members are pictured celebrating during the early days. (Courtesy of the Royal Esquire Club.)

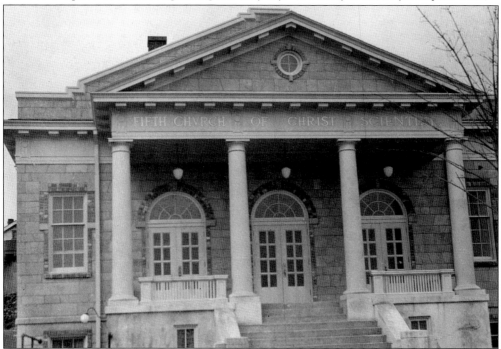

Christian Scientists, long active in Columbia City, opened the Fifth Church of Christ Scientist, Seattle on Columbia Park in 1921. Built for $23,000, the Greek Revival structure at Alaska Street and Rainier Avenue was purchased for $324,000 in 1995 by SouthEast Effective Development and converted into a nonprofit performing arts center.

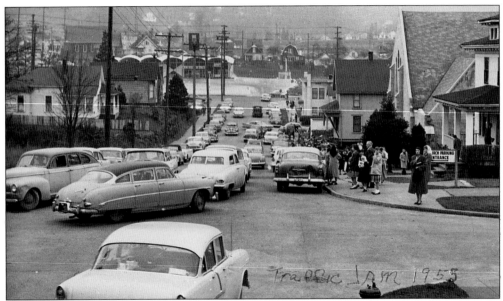

Bethlehem Lutheran Church celebrated its 90th anniversary in 1996. It was originally called the German Evangelical Bethlehem Church. The congregation's growth in the 1940s caused regular traffic jams before and after services. Bethlehem Lutheran was known for the Ladies Aid Society, the Dorcas Sewing Group, and missionary work in Papua, New Guinea. Today, the building is occupied by Columbia City Church of Hope.

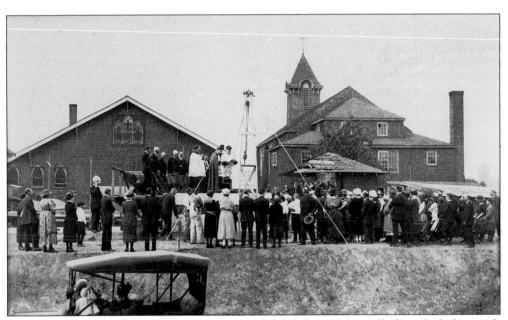

Over a century ago, Florence O'Rourke petitioned the Bishop of Nisqually for a Catholic parish in Hillman City. Bishop O'Dea responded by sending Father Lorigan, who broke ground for St. Edward Church in 1906. Not long after, the parish dedicated a hall behind the church, pictured here. The parish and its school became the spiritual home for Irish Catholics, among others. More recently, the church has welcomed immigrants from Asia and the South Pacific.

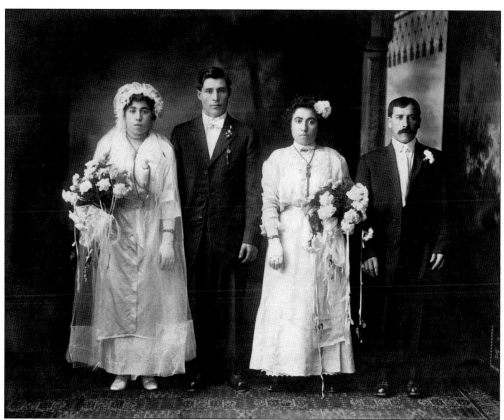

Our Lady of Mount Virgin Catholic Church was the hub of the Italian community in the valley. In 1914, a new Florentine-style church was built by parishioners and paid for in part by Father Lodovico Caramello, who enlisted family and friends in his native Turin to help fund the construction. Caramello was credited with molding diverse groups of Italian immigrants into a unified parish community in his 35 years as pastor. In recent decades, the church has opened its doors to Chinese, Hmong, and Native American groups. Mike and Josephine Eronemo (above, left) were married at Our Lady of Mount Virgin Church in 1915. The Eronemos lived in Garlic Gulch for over 50 years. (Courtesy of Patricelli family.)

Jewish communities in Seattle originally made their home in the Central District. However, beginning in the 1950s, many Orthodox Jewish families moved down to the Seward Park neighborhood. Ultimately, the synagogues themselves followed: Ezra Bessaroth, Sephardic Bikur Holim, and Bikur Cholim-Machzikay Hadath. Pictured here are historical Torahs at Sephardic Bikur Holim. (Courtesy of the Museum of History and Industry.)

Marion (Southard) Weiss, pictured with a kitten around 1912, pursued a career in social work before her 1926 marriage. After marrying local attorney Philip Weiss and moving to a home overlooking Lake Washington, she continued to be active in her field, serving as a commissioner for the Seattle Housing Authority and on the boards of Planned Parenthood, the League of Women Voters, and the Community Chest (today's United Way). Marion Weiss died in 1971.

Findlay Street Christian Church (Disciples of Christ) was established in 1906. After 100 years of ministry, the congregation voted to sell the Hillman City edifice and move to Beacon Hill. The congregation was more progressive than some other churches; women became early leaders. Today, the faith community welcomes all races and sexual orientations. Pictured are church members relaxing at a retreat near Mount Rainier during the 1930s.

Columbia Baptist Church at 36th Avenue and Edmunds Street was built in 1905. The east side of the building was originally on stilts over the creek that emptied into Wetmore Slough and Lake Washington. Here, children gather for a vacation Bible school in 1943. Like many of the big congregations, declining membership led to the sale of the church building in 1975. Today, it is a gathering space and home to a community organization.

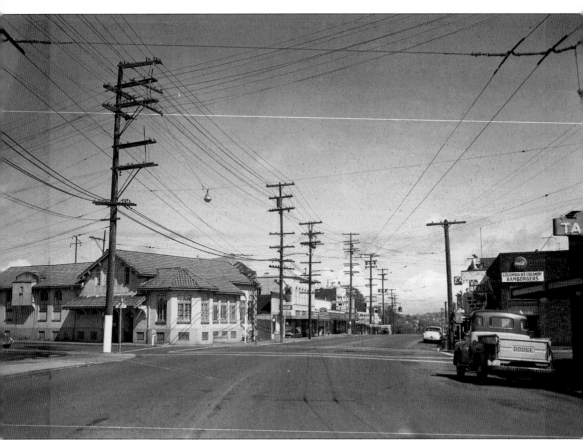

The Spanish mission-style structure on the corner of Hudson Street and Rainier Avenue was built as a police station by the City of Seattle in 1926. The building replaced the old Columbia City Hall, a relic of the community's brief incorporation (1893–1907). The new police precinct served as such for 34 years, keeping the peace in ways both large and small. Newspaper reports document the following incidents: "Boys who derailed a Rainier Valley [street] car at 51st south and Rainier Avenue last Saturday night by placing a rock in the switch were listed at the Columbia police station this week," and "Policemen grab yeggs [burglars] in Safeway Store." The building ceased functioning as a police post in 1960 when Seattle opened a new precinct for the south end in Georgetown. Since that time, it has seen a number of uses, including as an office for Seattle City Light, a voting precinct and meeting hall, a public health center, and a youth service agency.

Six

RECREATION AND CELEBRATION

The Rainier Valley has a long history of community celebration. From the early days of settlement, residents have found occasions to come together to play, socialize, and have a good time. Parades and festivals, such as the Rainier District Fiesta, the Rainier District Pow Wow, and the Rainier Valley Heritage Festival have coaxed successive generations out to have fun.

The valley was once the home of baseball in Seattle. Sicks' Stadium on Rainier Avenue (replacing the original Dugdale stadium) was a major local attraction for many years and home to the five-time Pacific Coast League champion Seattle Rainiers. Baseball hero and Rainier Valley native Fred Hutchinson played for the Rainiers, while Elvis Presley, Janis Joplin, and Seattle's own Jimi Hendrix all played concerts at the stadium. The stadium's last chance for glory came when Seattle received its first major-league expansion team, the Seattle Pilots, in 1968. The experiment lasted only one year. Sicks' Stadium was torn down in 1979.

Seward Park, one of the oldest and largest parks in the city, was the site of the enduring Rainier District Pow Wow festival (1934–1991). The spectacular park, with its stand of old growth timber, continues to draw families, sports enthusiasts, and wildlife viewers year round. Crowds flock to the waterfront during July and August for the annual Seafair celebrations, hydroplane races, and Blue Angel shows. A number of other events, including the Seattle Marathon, the Danskin Triathlon, and the Pista Sa Nayon Filipino festival take place along the shorefront.

Kubota Garden in the south part of the valley became the preeminent Japanese American landscape business in the area, despite internment of the Kubota family during World War II; today, it is an internationally recognized public garden and city historical landmark.

Several historical businesses continue to thrive in the valley, including Borracchini's Italian Bakery, Oberto Meats, Kusak Cut Glass Works, and Darigold. Others such as Hitt's Fireworks Factory, Vince's Italian Restaurant, The Beanery, and Chubby & Tubby, home of the bargain basement Christmas tree, have passed into memory.

Bathing beauties lift their skirts to wade in Lake Washington near the Brighton Beach neighborhood in 1905. The women may have been vacationing at the nearby Twin Firs Hotel, the former home of the Matthiesen family. Patrons would hop off the trolley at Wildwood Lane and follow a trail over the hill to the hotel overlooking Lake Washington. In 1889, Judge Everett Smith built a youth camp on the site with help from the YMCA; he carved a hollow stairway for the children in an enormous madrona tree. In 1920, Smith sold the property to the Seattle School District, which built the Martha Washington School. The residential school for troubled girls operated from 1921 to 1971. The shoreline is now the home of Martha Washington Park; today, both hotel and school are gone.

Masked revelers attend a 1911 ball at the original Mount Baker Park Improvement Club meeting hall. In 1914, the club moved to a newly built clubhouse next door that, with some remodeling, still stands today. The Improvement Club became today's Mount Baker Community Club. (Courtesy of Mount Baker Community Club.)

Adolph Schmick released his homemade hot-air balloon over Lake Washington for a Fourth of July celebration in 1912. This photograph was taken at a summer cottage owned by the Miller family, located where the Day Street Boat launch is currently under the Interstate-90 bridge. Over the years, the Miller family hosted many picnics and gatherings that often included fireworks from Hitt's Fireworks.

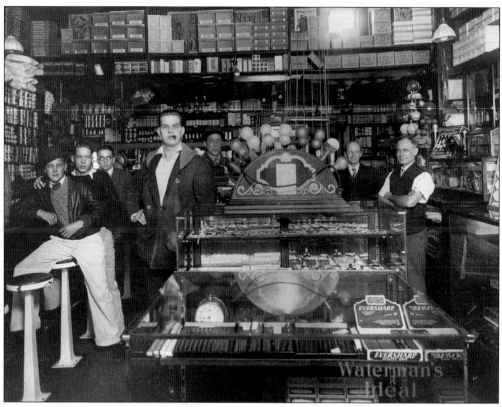

One of the earliest and most popular hang outs for Franklin High School students was the Beanery. Students like Eggs Voigt, fourth from the left in this 1929 photograph, could sidle up to the soda fountain for an ice cream sandwich or purchase new Spalding tennis balls before practice. The Beanery was largely a male bastion; it offered a room for females in the back. Kuehnoel's Triple XXX Root Beer drive-in on Rainier Avenue served a tasty hamburger and gave the Beanery stiff competition in later years. Two towering casks gave the lunch spot its nickname, the "Big Barrel." One motto was " 'I'm thirsty,' says Rex. 'Let's all go to the Triple XXX.' " Triple XXX root beer owed its success to Prohibition, when its parent company, a beer brewery, was forced to seek out a new business model.

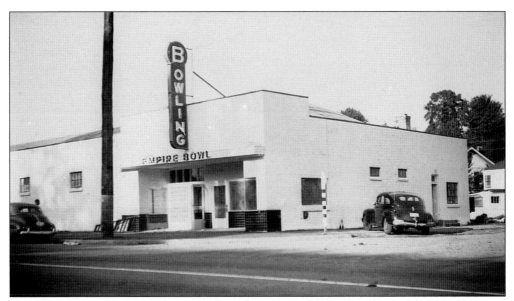

Llewellyn "Zeke" LeMay made his mark as the owner of Columbia Motors, but he also had a passion for bowling. In 1945, he sold his dealership and built the 10-lane Empire Bowling Alley on Empire Way, now Martin Luther King Jr. Way. This site is currently home to the Filipino Community Center of Seattle, which turned the fine wood lanes into a dance floor.

The valley was home to several movie theaters over the years including the Princess, the Pix, and Hillman City's American Theatre. This 1950 photograph shows the entrance to the Columbia Theater on Rainier Avenue in Columbia City. The actual theater was placed at the far rear of the building to comply with a city ordinance that required "amusements" to be at least 500 feet from schools.

Vince and Ada Mottola moved to Seattle from Naples as newlyweds. They opened Vince's Italian Restaurant and Pizzeria on Empire Way (now MLK) at Othello Street in 1957; six years later, they moved the popular eatery to Renton Avenue and Henderson Street, where it remained until closing in 2011. This 1963 promotional photograph features Vince, his daughter Pam (center), and a local model in Italian dress. (Courtesy of Mottola family.)

Svea Larson celebrates her birthday with 12 of her closest friends in 1910. Many of the girls probably attended Columbia School, which can be seen on the right. Like many properties in Columbia City at the time, the yard is below the level of the roadbed.

Columbia City mayor William W. Phalen declared that June 25, 1915, "will be known as Rainier Valley Fiesta and it will feature all the games, exhibitions and attractions suitable for an outdoor public galaday." Events were held throughout the day, including the Babcock and Ryan Carnival, a *Punch and Judy* show, pony rides, lantern slides, Cavanaugh's Band, and performances by the Eagle and Redmond drill teams. Prizes donated by local businesses included pails of lard, a barrel of ginger snaps, a box of Parisian sweets, and a ton of coal. Here, the Hitt family, proprietors of Hitt's Fireworks Company, festooned a few flags on the family car and joined the fun; company founder T.G. Hitt is at the wheel. The fiesta ran from 1915 to 1919. The program shown at right refers to "Sunset Highway," an old name for Rainier Avenue.

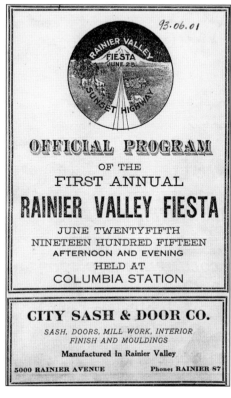

93.06.01

OFFICIAL PROGRAM

OF THE

FIRST ANNUAL

RAINIER VALLEY FIESTA

JUNE TWENTYFIFTH
NINETEEN HUNDRED FIFTEEN
AFTERNOON AND EVENING
HELD AT
COLUMBIA STATION

CITY SASH & DOOR CO.

SASH, DOORS, MILL WORK, INTERIOR FINISH AND MOULDINGS

Manufactured In Rainier Valley

5000 RAINIER AVENUE Phone: RAINIER 87

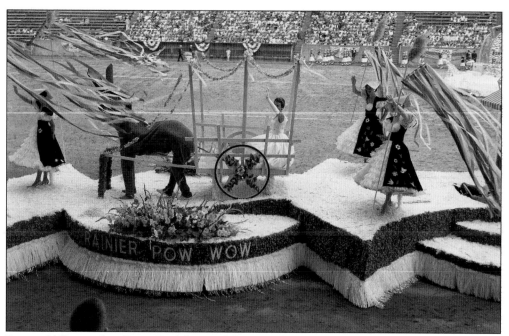

Rainier Valley resident Roger Ford designed floats for the Rainier District Business Men's Club for more than two decades, including this Italian village scene complete with a donkey. The floats served as colorful advertisements for the Rainier District Pow Wow and the valley. Ford's final entry for the now-renamed Rainier Valley Chamber of Commerce was an award winning King Tut–themed entry in 1978.

The Rainier Valley Heritage Festival and Parade has been part of summer since 1993. Sponsored by the Rainier Chamber of Commerce, this community event celebrates all things Rainier Valley, from Chinese dragons to these young steppers, the Rainier White Ravens. (Courtesy of Alan Humphrey.)

Hitt's Fireworks Company became internationally known, developing new explosive products every year at their factory overlooking Columbia City. The company created pyrotechnics for the movie *Gone with the Wind*, as well as fireworks for shows at Green Lake and Ivar's Fourth of July celebrations until 1974. They presented shows at Sicks' Stadium and at Playland amusement park, just to the north of Seattle. Their fireworks shows were large-scale productions: for some major celebrations, the Hitts built elaborate sets up to 400 feet long, which served as platforms for the fireworks show. The sets carried themes such as "Mt. Fuji," "Fires of Freedom," and the "Birth of America," often with lines of chorus girls and military drill teams performing between the explosions. Their signature grand finale was to blow up the set in a ball of fire, igniting the skies with explosions of color and showers of rockets.

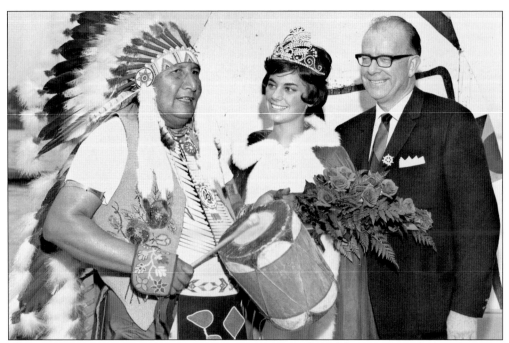

The Rainier District Pow Wow was a picnic, a party, and a celebration. Hugely popular in its heyday, the powwow attracted crowds as large as 30,000 (in 1950) to Seward Park for races, beauty pageants (including one for babies), pie-eating contests, and signature events like the husband-calling contest. Hitt's supplied the fireworks. The Rainier District Pow Wow borrowed icons of Native American culture, both in name and activities. Most years, an Indian chief was persuaded to lend a hand with the festivities. In the image above, Chief White Eagle shares the spotlight with Rainier District Pow Wow queen Robin Armstrong and state legislator John L. O'Brien in 1964. (Both, courtesy of O'Brien family.)

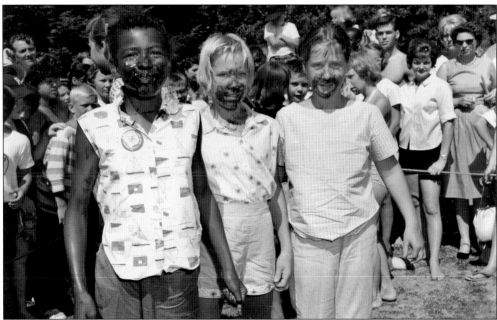

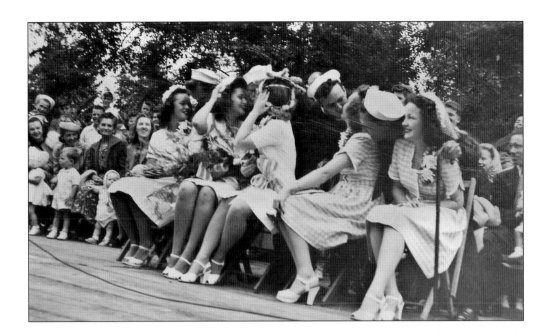

Pictured above in 1945, beauty contestants convey the thanks of a grateful nation to visiting sailors. Meanwhile, candidates for the beautiful baby contest wait patiently at left. Below, O'Brien awards the ribbon to the winner of the women's swim competition in 1952. O'Brien and numerous local businessmen (and eventually women) spent months each year organizing and fundraising for the valley's premier summer event. The local papers could not get enough of the Pow Wow, no doubt due to photo opportunities such as these. (Below, courtesy of O'Brien family.)

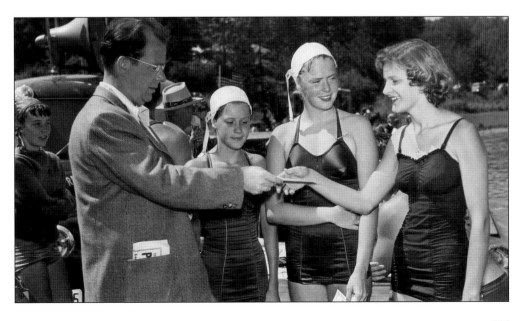

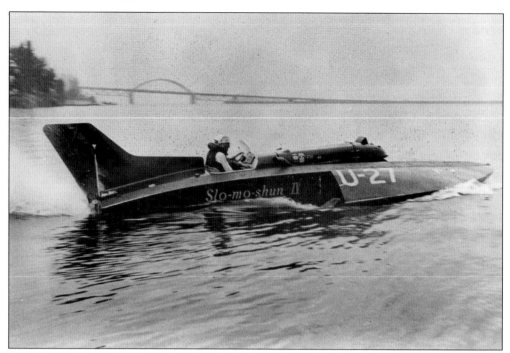

Stan Sayres Memorial Park, or "Pits," in the Lakewood neighborhood was named in 1957 for the man who brought hydroplane racing to Seattle in 1954. In his unlimited-class powerboat, *Slo-Mo-Shun IV*, seen here in 1953, Sayres won five Gold Cups and set a speed record of 178.48 miles per hour. The hydro races on Lake Washington are an integral part of Seattle's summer Seafair festival. (Courtesy of Hydroplane and Raceboat Museum.)

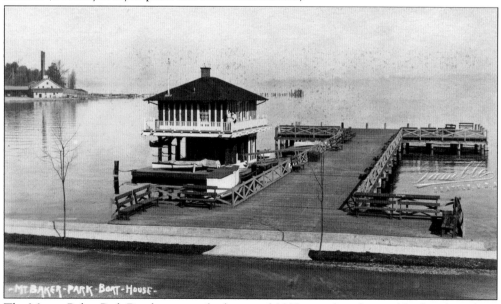

The Mount Baker Park Boathouse was built around 1908 as a place for neighborhood residents to keep their watercraft free of cost. The upper story of the boathouse housed a family whose job included helping to keep the popular park and beach free of undesirables. Walkways led from the beach up to the planned community of Mount Baker Park.

Seward Park officially opened to the public in 1911. By 1915, the *Rainier Valley Citizen* boasted that "Seward Park is already a favorite resort for those picnickers who want to get fartherst [sic] away from the turmoil of city life in the shortest possible distance, for this park is a veritable wooded wilderness." In this 1917 photograph, a seaplane rests in Andrews Bay on the northern perimeter of the park.

Alfred J. Pritchard purchased a small island just off the shore of Lake Washington, spanned the slough with a footbridge, and developed the island into an attractive forest estate. When the Lake Washington Ship Canal opened in 1917, the lake level was lowered by nine feet, effectively draining the Dunlap Slough and connecting Pritchard's Island to the mainland. Millie Pritchard, Alfred's daughter, is shown enjoying the water in 1917.

Fujitaro Kubota, pictured here on the left in the 1930s, shows his garden to visitors. The Japanese caption reads, "Looking at the mountain behind our house." Kubota emigrated from Japan in 1907 and, in 1927, bought five acres of logged-off swampland in the Rainier Beach neighborhood as a home for his family, his business, and his garden. During the family's World War II internment, Kubota supervised the building of a community park at Camp Minidoka in Idaho. The Kubotas were able to return to Seattle after the war and reclaim their property. In 1981, the Kubota Garden was declared a Seattle historical landmark. A unique combination of eastern and western gardening concepts, the 20-acre garden is now a public park, owned and operated by the City of Seattle. It is open every day free of charge, offering tranquility and beauty to all visitors. (Courtesy of the Kubota Garden Foundation.)

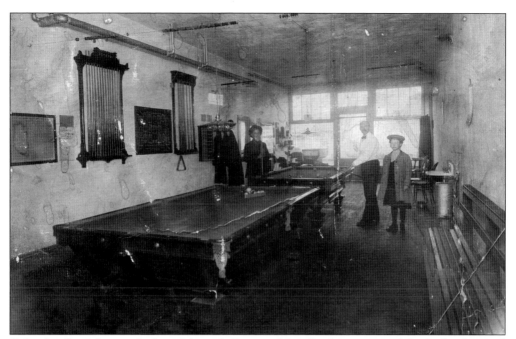

Columbia City's favorite barbers, Menzo LaPorte and Lee Gardner, operated this barbershop and poolroom at 4915 Rainier Avenue South, pictured here in 1907. A pool table remained a fixture at this spot even after the barbers moved on. The building has housed businesses such as the Boar's Nest, the Pink Poodle, and most recently, Angie's Tavern.

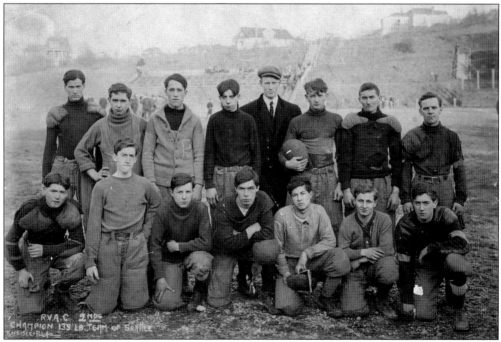

The Rainier Valley Athletic Club formed in 1908 to promote sports teams in the valley. They competed with other teams throughout the city in basketball, baseball, wrestling, boxing, and football. The second team, pictured here, won the 1910 Seattle football championship for 135-pound teams.

Whitworth School opened in 1908, replacing the one-room Hillman School in the Hillman City neighborhood. The boys' baseball team won the city championship in 1911. The school offered grades first through eighth, a common practice for elementary schools before junior high schools became the norm in the 1950s.

Columbia Congregational Church, founded in 1896, sponsored this 1914 girls' basketball team. In 1913, Reverend Wirth accepted the challenge of increasing church membership from a low of 20 active people. With an ambitious program for all ages including youth sports, the congregation flourished and built a larger church in 1922. Female athletes typically wore middy blouses and bloomers at that time and for many years to come.

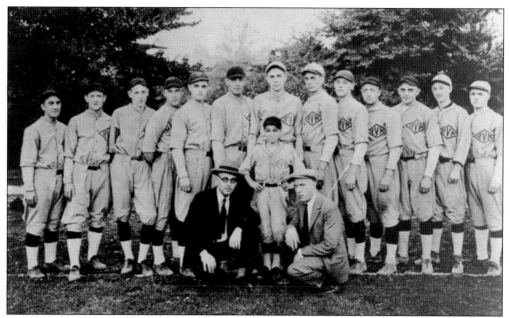

Most business associations sponsored youth sports clubs, and the Rainier Valley Merchants Association was no exception. This boys' baseball team had a record of 21-2 in 1925 and won the city's independent baseball championship. Freeman Heater, owner of the Heater Glove Factory and secretary of the club, is kneeling on the left. Young Jean Dell, front row center, was the team's mascot.

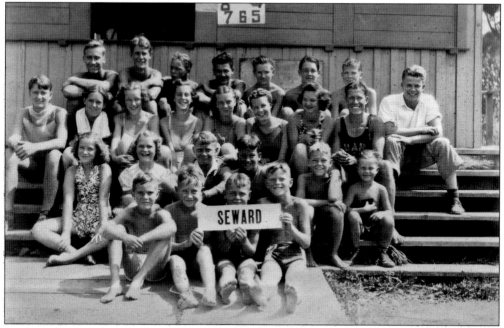

Seward Park has long been a favorite swimming spot for children and adults willing to brave the cold lake waters. The lowering of the lake in 1917 exposed the wide, grassy meadow that now leads to the swimming beach. This 1940 swim team poses on the steps of the bathhouse, constructed in 1927.

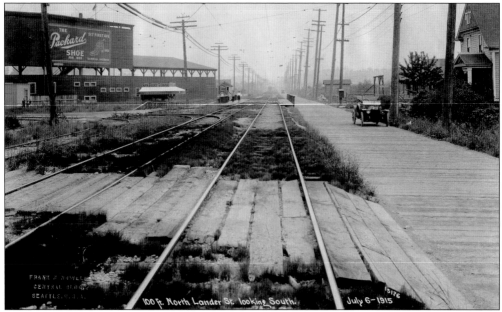

Dugdale Park, named for owner Daniel Dugdale, opened with a capacity of 15,000 at the corner of McClellan Street and Rainier Avenue in 1913. It was the west coast's first double-decker stadium. Special streetcars dropped fans off on a spur track, as pictured here in 1915. On July 4, 1932, Robert Bruce Driscoll, the "Pacific Coast Fire Bug," burned down the stadium. Six years later, Sicks' Stadium was built on the same site.

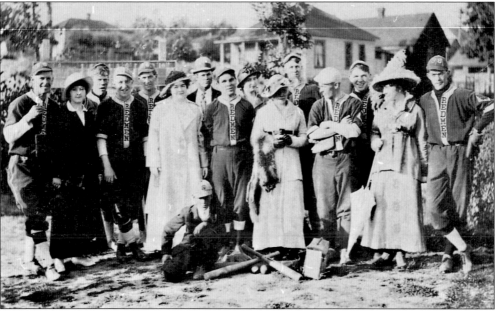

The Rainier Valley's Redmen baseball team played in a Seattle amateur league from 1915 to 1920. League members included teams from North Bend, Port Orchard, Rainier Beach, Bothell, and Kirkland. The team also played games against local Japanese and African American squads. The Redmen played at Columbia Playfield, Lower Woodland Park, and Alki Playfield, at one point winning 15 out of 16 games.

Legendary baseball pitcher and Franklin High School graduate Fred Hutchinson joined the Seattle Rainiers in 1938. The 19-year-old Hutchinson, seen here, caused an immediate sensation, winning a league-best 25 games and that season's Minor League Player of the Year award. Hutchinson died of cancer in 1964 at the age of 45 after a career that included managing the Rainiers, the Detroit Tigers, the St. Louis Cardinals, and the Cincinnati Reds. He may have had his greatest success with the Reds, leading the team to a pennant win in 1961. Following his death, the Reds retired his number (1) and he was inducted into the Cincinnati Reds Hall of Fame. In 1975, Fred's brother, Dr. William Hutchinson, founded the Fred Hutchinson Cancer Research Center in Seattle in his memory. On December 24, 1999, the *Seattle Post-Intelligencer* named Hutchinson Seattle's "Athlete of the 20th Century." (Courtesy of David Eskenazi Collection.)

Alice Brougham, daughter of Seattle sportswriter Royal Brougham, was the unofficial mascot of the Seattle Indians and Rainiers baseball teams. She is pictured here with her future husband, pitcher Dewey Soriano (left), and Dick "Kewpie" Barrett in 1942. Kewpie pitched for the Seattle Indians and Rainiers, helping the latter bring home championships in 1939, 1940, and 1941. He pitched a perfect game in 1948 at the age of 42. A baseball card with his likeness is part of an 89-card collectible set of Pacific Coast League players issued during the 1930s and 1940s. The cards were sponsored by Signal Gasoline and drawn by Al Demaree, a former pitcher for the New York Giants and, later, a sports cartoonist.

Local brewer Emil Sick built Sicks' Stadium on the site of the old Dugdale Stadium and named it for his family. The new 11,000 capacity ballpark opened on June 15, 1938. It was the home of Sick's baseball team, the Seattle Rainiers, as well as, briefly, the Seattle Steelheads, a Negro League team. The stadium was an immensely popular attraction in the city, serving also as the locale for concerts by Elvis Presley, Janis Joplin, and hometown boy Jimi Hendrix. On April 11, 1968, the expansion major league Seattle Pilots made their debut at Sicks' Stadium under the management of Dewey Soriano. Although they won their home opener, the team finished in last place in the American League West and was promptly sold to Milwaukee. Nine years later, Sicks' Stadium was torn down and replaced with a home improvement store. (Both, courtesy of David Eskenazi collection.)

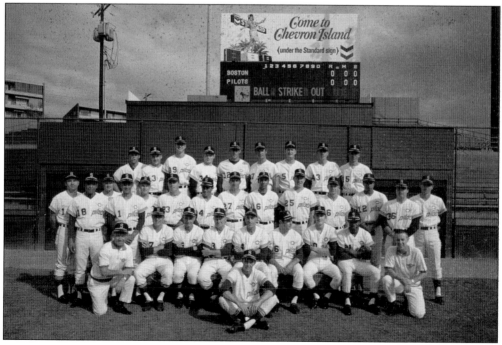

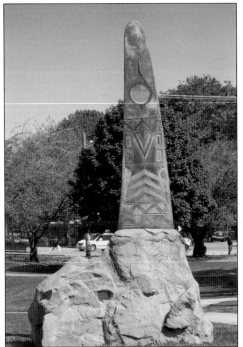

The Spirit of Washington, a cast-bronze monument depicting an orca's fin engraved with a stylized figure of a Northwest tribal member, stands in Columbia Park behind the library. The work by Native American artist Martin Oliver was commissioned and placed by SEEDArts and the Seattle Art Commission in 1991, with support from local merchants. The monument honors the original inhabitants of the valley. It is positioned adjacent to a curved walkway, which traces, at least symbolically, the route of the creek that once ran through the park on its way to Lake Washington. In 2005, a group of local fifth graders brought the creek to the attention of the community. Due in part to their efforts, the Seattle Parks Department incorporated the path of the historical stream into an improvement project for Columbia Park. The creek, like many pieces of our collective history, may be neither gone nor forgotten—it may still run underground. (Courtesy of Alan Humphrey.)

The Pioneers of Columbia City formed as a social club in 1891 in the very early days of settlement. Meetings were held in homes, the Columbia Congregational Church, and at Fraternity Hall. Pioneer president H.A. Hastings delivered a speech at the 1909 annual meeting through a Graphophone, a version of the new-fangled phonograph. The Rainier Valley Historical Society inherited the holdings of the Pioneers of Columbia City in 1993. Musicians performing at the Pioneers of Columbia City's 1972 meeting are, from left to right, Wayne Parker, piano; Cy Stephens, tambourine; and Darryl Anderson, ukulele. Famed sportswriter Royal Brougham keeps time.

ABOUT OUR ORGANIZATION

The Rainier Valley Historical Society preserves, exhibits, and interprets the history and heritage of the Rainier Valley and its people. We are a not-for-profit organization funded by membership fees, donations, and operating funds from King County 4Culture.

You may contact us at:
206-723-1663
Email: rvhsoffice@aol.com
P O Box 18143
Seattle, WA 98118
www.RainierValleyHistory.org

DISCOVER THOUSANDS OF LOCAL HISTORY BOOKS FEATURING MILLIONS OF VINTAGE IMAGES

Arcadia Publishing, the leading local history publisher in the United States, is committed to making history accessible and meaningful through publishing books that celebrate and preserve the heritage of America's people and places.

Find more books like this at
www.arcadiapublishing.com

Search for your hometown history, your old stomping grounds, and even your favorite sports team.

Consistent with our mission to preserve history on a local level, this book was printed in South Carolina on American-made paper and manufactured entirely in the United States. Products carrying the accredited Forest Stewardship Council (FSC) label are printed on 100 percent FSC-certified paper.

MADE IN THE

USA